Art Architecture Design

ROME

edited by Elke Buscher

teNeues

ART

ARCHITECTURE

DESIGN

ROME:

Content

No other city in the world can compete with Rome when it comes to art and architecture. The multitude of treasures range from antiquity to the present and run the gamut from the Colosseum, the Pantheon, and the Trevi Fountain all the way to the contemporary church of Dio Padre Misericordioso designed by Richard Meier. In the city center, you cannot take a step without bumping into a column, fountain, church façade, or at least a figure of a saint in a palazzo niche. Not traditionally known as a center of modern design, Rome does have a reputation for artisan crafts. In the narrow streets surrounding Campo dei Fiori, many artisans hand-craft unique furniture and accessory items; you can watch them ply their trade in their workshops. The modern age, however, has finally arrived in Rome—in architecture, art, and design. In this book, we showcase these new treasures as well as the unforgettable classics of the past.

Keine andere Stadt der Welt verfügt über eine solche Vielfalt an Kunst und Architektur wie Rom. Von der Antike bis zur Gegenwart reichen die zahlreichen Schätze – darunter das Kolosseum, das Pantheon, der Trevibrunnen und die moderne Kirche Dio Padre Misericordioso von Richard Meier. Man kann im Zentrum kaum einen Schritt machen, ohne über eine Säule, einen Brunnen, eine Kirchenfassade oder zumindest eine Heiligenfigur in der Nische eines Palazzos zu stolpern. Dagegen hat sich Rom als Designstadt bisher nicht sonderlich hervorgetan. Die Hauptstadt ist eher für ihre Handwerkskunst bekannt. Rund um den Campo dei Fiori kann man in den hübschen Gassen vielen Handwerkern bei der Arbeit zusehen, die in kleinen Mengen Möbel oder Accessoires herstellen. Doch inzwischen hat auch die Moderne Einzug gehalten – sei es bei der Architektur, sei es bei der Kunst, sei es beim Design. Und diese neuen Pretiosen möchten wir Ihnen hier ebenso vorstellen wie die unvergleichlichen Klassiker aus der Vergangenheit.

Rome dispose d'une diversité artistique et architecturale unique. Ses nombreux trésors comme le Colisée, le Panthéon, la Fontaine de Trevi et l'église moderne Dio Padre Misericordioso de Richard Meier sont issus de toutes les époques, de l'Antiquité à nos jours. On ne peut pas faire un pas dans le centre sans être ébloui par une colonne, fontaine, façade d'église ou une figure sacrée dans la niche d'un palais. Cependant, Rome ne s'est pas particulièrement affirmée en tant que ville du design. La capitale est surtout réputée pour son artisanat d'art. En parcourant les ruelles aux alentours de Campo dei Fiori, on peut admirer le travail d'artisans, qui produisent meubles et accessoires sous vos yeux. Entre-temps, que ce soit dans l'architecture, l'art ou le design, la modernité a trouvé sa place. Et nous aimerions vous la faire découvrir, tout comme les grands classiques inimitables du passé.

Nessun'altra città al mondo può vantare un patrimonio artistico e architettonico ricco come quello di Roma. Gli innumerevoli tesori di questa città spaziano dall'antichità al presente – tra essi il Colosseo, il Pantheon, la Fontana di Trevi e la moderna chiesa Dio Padre Misericordioso, progettata da Richard Meier. Nel centro non si può quasi muovere un passo senza imbattersi in una colonna, una fontana, una facciata di una chiesa o quantomeno la statua di un santo inquadrata nella nicchia di un palazzo. Per contro, finora Roma non si è distinta in modo particolare come città del design. La capitale è nota piuttosto per le sue opere di artigianato: nei graziosi vicoli che si diramano da Campo dei Fiori si possono spesso vedere artigiani intenti a confezionare mobili e accessori in piccole quantità. Ma pian piano stanno avanzando anche le tendenze dell'era moderna – nell'architettura, nell'arte e nel design. E sono proprio le gemme dei giorni nostri che vogliamo presentarvi in questo volume, accanto agli intramontabili classici del passato

A

It is difficult to summarize art in Rome in just a few sentences—the spectrum is simply too vast. It starts with ancient statues and extraordinary frescoes like the ones in Casa di Augusto and Palazzo Massimo alle Terme, continues with the decorative elements found in numerous medieval churches, and extends to the countless collections and museums. The most important of these are the Vatican Museums, for many the most significant collection of art in the world. Overpowered by the dominant influences of ancient, medieval, and modern art, contemporary art in Rome has been on the sidelines for many years—yet this is beginning to change. Important milestones in this evolution were the opening of the MACRO annex in Testaccio and the Zaha Hadid-designed MAXXI that merges art and architecture into a symbiotic whole. Another driving force is The Road to Contemporary Art; this unique show was first held in 2008 and is fast becoming a focal point of the Roman art scene.

Es ist schwierig, die Kunst in Rom in wenigen Sätzen zu umreißen – das Spektrum ist einfach zu groß. Es beginnt bei antiken Statuen und außergewöhnlichen Fresken, die zum Beispiel in der Casa di Augusto oder im Palazzo Massimo alle Terme zu besichtigen sind. Es geht weiter bei der Ausschmückung vieler mittelalterlicher Kirchen bis hin zu zahllosen Sammlungen und Museen – darunter allen voran die Vatikanischen Museen, die viele für die bedeutendste Kunstsammlung der Welt halten. Bei einer solchen Dominanz antiker, mittelalterlicher und neuzeitlicher Werke hatte es die zeitgenössische Kunst in Rom lange schwer. Doch jetzt genießt auch sie einen größeren Stellenwert. Neben der Eröffnung des zweiten Gebäudes des MACRO Testaccio und des Museums von Zaha Hadid, das Kunst und Architektur symbiotisch zusammenführt, war einer der Auslöser auch die 2008 ins Leben gerufene und qualitativ hochwertige Messe The Road to Contemporary Art. Sie entwickelt sich immer mehr zu einem Fixpunkt in der Kunstszene.

Décrire l'art romain ne se fait pas en quelques lignes – sa diversité est bien trop importante. Commençons par les statues antiques et les fresques exceptionnelles que l'on peut voir par exemple dans la Casa di Augusto ou au Palazzo Massimo alle Terme. Continuons avec la décoration d'églises du Moyen-âge et les innombrables collections et musées comme ceux du Vatican qui abritent celle que l'on considère comme la collection d'art la plus importante au monde. Avec une telle dominance des œuvres antiques, moyenâgeuses et modernes, l'art contemporain a longtemps eu du mal à s'imposer. On lui accorde cependant aujourd'hui une plus grande valeur. Ce revirement fut déclenché par l'inauguration du deuxième bâtiment du MACRO Testaccio et du musée de Zaha Hadid, où art et architecture sont en parfaite symbiose, mais également par la création en 2008 du salon d'exposition The Road to Contemporary Art qui est devenu depuis le repère de la scène artistique.

È difficile cercare di riassumere l'arte di Roma in poche frasi: il panorama è semplicemente troppo ampio. A cominciare dalle statue antiche e dagli straordinari affreschi che si possono ammirare ad esempio nella Casa di Augusto o al Palazzo Massimo alle Terme, per proseguire con le decorazioni che impreziosiscono molte chiese medievali fino alle innumerevoli collezioni d'arte e ai tanti musei – primi fra tutti i Musei Vaticani, considerati da molti la raccolta di opere d'arte più importante al mondo. Di fronte a una tale preponderanza di capolavori antichi, medievali e d'epoca moderna, l'arte contemporanea a Roma è rimasta a lungo in secondo piano. Ma ora sta acquisendo maggiore importanza. Oltre all'apertura del secondo edificio del MACRO Testaccio e del museo di Zaha Hadid, che mette in simbiosi arte e architettura, ha svolto un ruolo decisivo in tal senso la prestigiosa fiera The Road to Contemporary Art presentata nel 2008. Un evento ormai sempre più radicato nel panorama artistico.

IL GABBIANO

Via della Frezza 51 // Centro Storico
Tel.: +39 06 32 27 04 9
www.galleriailgabbiano.com

Tue–Sat 11 am to 1.30 pm
and 4 pm to 7.30 pm
Bus 590 Ripetta/Fiume
Bus 628 Passeggiata Ripetta

Since its founding in 1967, Il Gabbiano has organized 200 shows featuring artists such as Georges Braque, Roy Lichtenstein, and Robert Rauschenberg. The gallery has had a strong relationship with American artists since it opened a branch in New York in the early 1980s. Yet Il Gabbiano is more than a gallery—it is also a meeting place for professionals working in culture and the arts.

Seit ihrer Gründung im Jahr 1967 hat die Galerie Il Gabbiano knapp 200 Ausstellungen organisiert, darunter von Künstlern wie Georges Braque, Roy Lichtenstein oder Robert Rauschenberg. In der Tat hat die Galerie einen starken Bezug zu amerikanischen Künstlern, seit sie Anfang der 80er Jahre eine Dependance in New York eröffnete. Ganz explizit versteht sich Il Gabbiano aber nicht nur als Galerie, sondern auch als Treffpunkt für Kunst- und Kulturschaffende.

Depuis son ouverture en 1967, la galerie Il Gabbiano a accueilli environ 200 expositions d'œuvres d'artistes tels que Georges Braque, Roy Lichtenstein ou Robert Rauschenberg. La galerie présente des artistes américains, surtout depuis l'ouverture d'une succursale à New York dans les années 80. Il Gabiano est plus qu'une simple galerie, elle est également un point de rencontre pour les créateurs culturels et artistiques.

Dalla sua fondazione nel 1967 a oggi la galleria Il Gabbiano ha organizzato quasi 200 mostre, tra cui di artisti come Georges Braque, Roy Lichtenstein o Robert Rauschenberg. Da quando ha aperto una sede a New York all'inizio degli anni 80, la galleria ha infatti una particolare affinità con gli artisti americani. Il Gabbiano si considera non soltanto una galleria, ma anche un punto d'incontro per i protagonisti della vita artistica

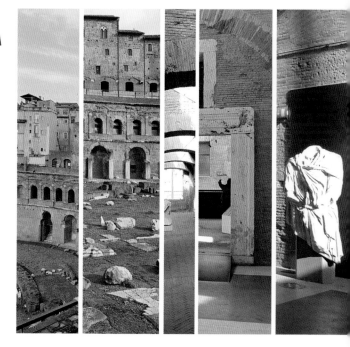

MERCATI DI TRAIANO

Via IV Novembre 94 // Centro Storico
Tel.: +39 06 06 08
www.mercatiditraiano.it

Tue–Sun 9 am to 7 pm
Bus 40 Nazionale / Quirinale
Bus 60 Fori Imperiali / Campidoglio

By the beginning of the 2nd century, Rome needed a new commerce area in addition to the Roman Forum; this was the impetus for the multilevel Trajan's Market, designed by architect Apollodorus. Tradespeople advertised their wares in 150 shops, selling flowers, wine, fruit, vegetables, spices, and other products. Today Trajan's Market houses the Museum of the Imperial Forums with over 170 original marble fragments of the imperial forums as well as a few limestone casts.

Zu Beginn des 2. Jahrhunderts war es nötig geworden, neben dem Forum Romanum noch einen weiteren Handelsplatz zu schaffen – deshalb errichtete der Architekt Apollodor die Trajansmärkte, die sich auf mehrere Ebenen verteilen. In rund 150 Läden konnten die Händler unter anderem Blumen, Wein, Obst, Gemüse und Gewürze anpreisen. Heute beherbergen die Märkte das Museo dei Fori Imperiali, mit über 170 marmornen Originalfragmenten der Kaiserforen sowie einigen Kalkabgüssen.

À l'orée du IIe siècle, la nécessité d'une nouvelle place commerçante à côté du Forum Romanum fut décrétée. L'architecte Apollodor érigea donc les Marchés de Trajan qui s'étendent sur plusieurs niveaux. Les commerçants de 150 échoppes y vantaient leurs fleurs, vins, fruits, légumes et épices. Aujourd'hui, on y trouve le Museo dei Fori Imperiali où l'on peut admirer plus de 170 fragments originaux en marbre des forums impériaux ainsi que des moulages en pierre

All'inizio del II secolo si rese necessario costruire un altro centro di attività commerciali da affiancare al Foro Romano – fu così che l'architetto Apollodoro progettò i Mercati di Traiano. Questi edifici distribuiti su più piani contavano circa 150 botteghe in cui i commercianti vendevano fiori, vino, frutta, verdura, spezie e molto altro. Oggi i mercati ospitano il Museo deo Fori Imperiali, con oltre 170 frammenti originari di marmo e alcuni calchi dei Fori Imperiali

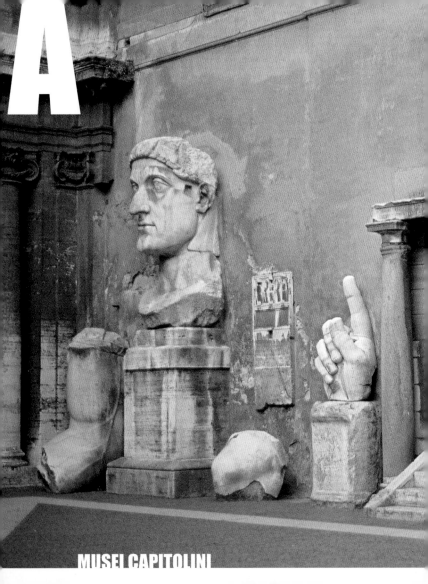

A

MUSEI CAPITOLINI

MUSEI CAPITOLINI

Piazza del Campidoglio 1 // Centro Storico
Tel.: +39 06 06 08
www.museicapitolini.org

Tue–Sun 9 am to 8 pm
Bus 64 Piazza Venezia
Bus 81 Ara or Bus 170 Ara Coeli / Piazza Venezia

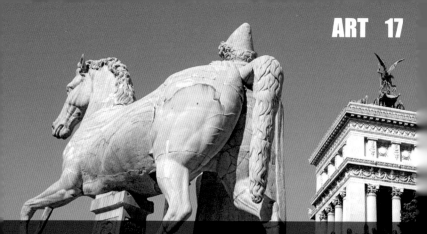

None other than Michelangelo designed the Palazzo Senatorio and the Piazza del Campidoglio. In front of it, a copy of the famed equestrian statue of Marcus Aurelius is the centerpiece of the Piazza. The original is housed in the Palazzo dei Conservatori, which together with the Palazzo Nuovo form the Capitoline Museums. Antique bronzes donated by Pope Sixtus IV in 1471 make these the oldest museums in the world. Just below the piazza you'll have a fantastic view over the Roman Forum.

Kein Geringerer als Michelangelo entwarf den Senatorenpalast und den davor liegenden Kapitolsplatz, in dessen Mitte eine Kopie der Reiterstatue von Mark Aurel steht. Das Original befindet sich im Konservatorenpalast, der mit dem Palazzo Nuovo zusammen die Kapitolinischen Museen bildet. Dank einer Schenkung von antiken Bronzeplastiken durch Papst Sixtus' IV. im Jahr 1471 gelten sie als das älteste Museum der Welt. Etwas unterhalb des Platzes bietet sich ein phantastischer Blick über das Forum Romanum.

Le Palais du Sénateur et la place du Capitole, au centre de laquelle trône une copie de la statue équestre de Marc-Aurèle, ont été conçus par nul autre que le grand Michel-Ange. L'original est exposé dans le Palais des Conservateurs qui constitue, avec le Palazzo Nuevo, l'ensemble des musées du Capitole. Grâce à la donation de figures en bronze du Pape Sixtus IV en 1471, ces musées sont considérés comme les plus anciens au monde. En contrebas de la place, on peut admirer

Il Palazzo Senatorio e l'antistante Piazza del Campidoglio, dominata al centro da una copia della statua equestre di Marco Aurelio, furono progettati niente meno che da Michelangelo. La statua originale si trova nel Palazzo dei Conservatori, che con Palazzo Nuovo è sede dei Musei Capitolini. Grazie a una donazione di antichi bronzi effettuata da Papa Sisto IV nel 1471, questo è il più antico museo del mondo. Leggermente sotto la piazza si apre una splendida vista sul Foro Ro-

PALAZZO BARBERINI –
GALLERIA NAZIONALE D'ARTE ANTICA

Via delle Quattro Fontane 13 // Centro Storico
Tel.: +39 06 32 81 0
www.galleriaborghese.it/barberini/it/

Tue–Sun 8.30 am to 7.30 pm
Metro A Barberini

After Pope Urban VIII became pope in 1625, he commissioned Maderno, Borromini, and Bernini to build the Palazzo Barberini. For him, grand celebrations and self-aggrandizement were more important than art—hence the "Allegory of Divine Providence and Barberini Power" ceiling fresco that depicts the importance of the Barberini family. Since World War II, the National Gallery has exhibited major paintings here, featuring mainly Italian masters of the 13th to 18th centuries.

Gleich nachdem Papst Urban VIII. im Jahr 1625 sein Pontifikat angetreten hatte, ließ er von Maderno, Borromini und Bernini den Palazzo Barberini bauen. Wichtiger als die Kunst waren ihm allerdings große Feste und eine theatralische Selbstdarstellung – daher das Deckengemälde „Triumph der göttlichen Vorsehung" über die Bedeutung der Barberini. Seit dem Zweiten Weltkrieg zeigt hier nun die Nationalgalerie bedeutende Gemälde vor allem italienischer Meister des 13. bis 18. Jahrhunderts.

Au début de son pontificat en 1625, le Pape Urban VIII ordonna la construction du palais Barberini aux architectes Maderno, Borromini et Bernini. Féru d'art mais surtout des grandes célébrations, il aimait se présenter de manière théâtrale, d'où la fresque au plafond illustrant « le Triomphe de la Divine Providence », représentant l'importance des Barberini. Depuis la 2e Guerre Mondiale, la galerie nationale y expose surtout des œuvres d'artistes italiens du 13e au 18e siècle

Nel 1625, poco dopo l' inizio del suo pontificato, Papa Urbano VIII commissionò a Maderno, Borromini e Bernini la costruzione di Palazzo Barberini. Più che l'arte, per lui contavano i grandi ricevimenti in cui mettere in mostra la sua magnificenza – da qui l'affresco "Trionfo della Divina Provvidenza" che abbellisce il soffitto. Dalla seconda guerra mondiale la Galleria Nazionale vi espone prestigiosi dipinti di artisti soprattutto italiani realizzati tra il XIII e il XVIII secolo.

Built in the 19th century, Palazzo delle Esposizioni stages several exhibitions each year, primarily on modern and contemporary art as well as photography. Three self-contained areas on two levels, generously proportioned and equipped with state-of-the-art technology since the 2007 restoration, are available for this purpose. Films relating to the current exhibition program are shown in the palazzo's own movie theater; admission for the movies is free of charge for all visitors of the Palazzo.

Der Palazzo delle Esposizioni aus dem 19. Jahrhundert zeigt mehrmals im Jahr Ausstellungen vorwiegend zu moderner und zeitgenössischer Kunst sowie zu Fotografie. Drei voneinander unabhängige, großzügige Bereiche auf zwei Ebenen, die seit der Restaurierung im Jahr 2007 auch mit modernster Technik ausgestattet sind, stehen dafür zur Verfügung. Parallel zum jeweiligen Ausstellungsprogramm werden im hauseigenen Kino thematisch passende Filme gezeigt, die für alle Besucher des Palazzos kostenlos sind.

Le Palazzo delle Esosizioni, datant du XIXe siècle, accueille plusieurs fois dans l'année des expositions d'art moderne et contemporain ainsi que de photographie. Depuis sa rénovation en 2007, l'édifice, composé de trois parties indépendantes qui s'étendent sur deux niveaux, dispose d'une installation technique des plus modernes. Des films en accord avec le programme d'exposition parallèle sont diffusés dans le cinéma dont l'entrée est gratuite pour les visiteurs du Palazzo.

L'ottocentesco Palazzo delle Esposizioni allestisce diverse volte all'anno mostre dedicate soprattutto all'arte moderna e contemporanea e alla fotografia. A disposizione ci sono tre ampi spazi indipendenti sviluppati su due livelli, che un restauro avvenuto nel 2007 ha arricchito delle tecnologie più moderne. Nella sala cinematografica interna vengono inoltre proiettati film che si riallacciano al tema dell'esposizione del momento, gratuiti per tutti i visitatori del palazzo.

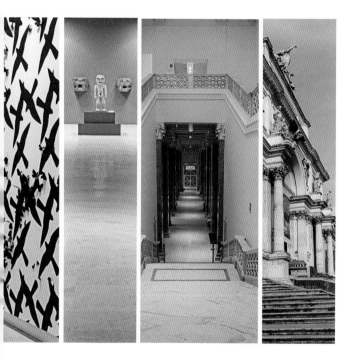

PALAZZO DELLE ESPOSIZIONI

Via Nazionale 194 // Centro Storico
Tel.: +39 06 39 96 75 00
www.palazzoesposizioni.it

Tue–Thu 10 am to 8 pm,
Fri–Sat 10 am to 10.30 pm, Sun 10 am to 8 pm
Bus 40, Bus 64, Bus 70, Bus 71 or
Bus 117 Nazionale / Palazzo Esposizioni

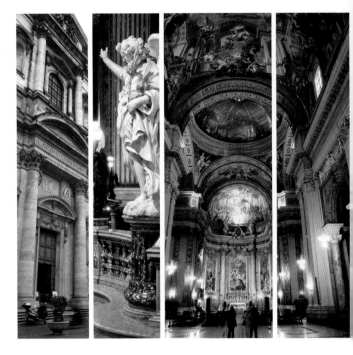

SANT'IGNAZIO DI LOYOLA

Piazza di Sant'Ignazio // Centro Storico
Tel.: +39 06 67 94 40 6

Daily 7.30 am to 12.30 am
and 3 pm to 7 pm
Bus 175 Corso / Minghetti

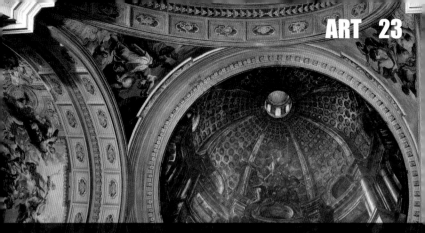

Immediately after Ignatius was canonized by Pope Gregor XV, the Jesuits chose a beautiful location to build the baroque church Sant'Ignazio as a tribute to the founder of the Jesuit Order. A ceiling fresco portraying Ignatius' being welcomed into paradise is a masterpiece of perspective painting by Andrea Pozzo, who seems to have transcended the boundaries between painting, stucco, and architecture. You can best experience this illusion by standing on the marble plate set into the floor.

Gleich nachdem Papst Gregor XV. Ignatius heiliggesprochen hatte, begannen die Jesuiten an einem entzückenden Platz mit dem Bau der barocken Kirche Sant'Ignazio, um ihren Ordensgründer zu verherrlichen. Das Deckenfresko, das die Aufnahme Ignatius' ins Paradies zeigt, ist ein Meisterwerk perspektivischer Malerei von Andrea Pozzo. Die Grenzen zwischen Malerei, Stuck und Architektur scheinen aufgehoben, was sich am besten erkennen lässt, wenn man auf einer in den Boden eingelassenen Marmorplatte steht.

Après la canonisation d'Ignace par le Pape Grégoire XV, les Jésuites entamèrent la construction de l'église baroque de Saint-Ignace sur une place magnifique, pour rendre hommage au fondateur de l'Ordre. La fresque au plafond illustrant l'entrée du Saint au paradis est un chef d'œuvre de la peinture perspectiviste d'Andrea Pozzo. Les frontières entre peinture, stuc et architecture disparaissent lorsqu'on admire la fresque d'une des plaques en marbre encastrées dans le sol.

All'indomani della santificazione di Ignazio ad opera di Papa Gregorio XV, su un'incantevole piazza i Gesuiti avviarono la costruzione della chiesa barocca di Sant'Ignazio in onore del fondatore dell'ordine. L'affresco sul soffitto raffigura l'ingresso del santo in Paradiso: un capolavoro della pittura prospettica realizzato da Andrea Pozzo in cui pittura, stucco e architettura sembrano fondersi, come si nota soprattutto stando in piedi su un disco di marmo posto nel pavimento della chiesa.

More than 500 years ago, Pope Julius II set out to create a street connecting the Vatican to the center of the city. Donato Bramante directed the implementation of this project, resulting in Via Giulia, 0,6 miles long and the first straight street in all of Rome. It is lined by many architectural treasures, including palaces and churches, which—thanks to open portals—invite exploration. The weekend is the best time to visit because there is less traffic.

Vor über 500 Jahren wollte Papst Julius II. eine Straße anlegen, um den Vatikan mit der Innenstadt zu verbinden – und Donato Bramante setzte seine Wünsche um. Es entstand die 1 km lange Via Giulia, die erste gerade Straße Roms. Sie wird gesäumt von zahlreichen architektonischen Schätzen, darunter Adelspaläste und Kirchen, die man – dank offener Portale – mitunter auch von innen erforschen kann. Besonders bietet sich ein solcher Spaziergang am verkehrsruhigeren Wochenende an.

Il y a plus de 500 ans, le Pape Jules II désira faire construire une avenue menant du Vatican au centre-ville ; Donato Bramante réalisa son vœu. La Via Giulia, longue de 1 km, vit le jour et fut la première avenue droite de Rome. Elle est bordée de trésors architecturaux dont de nobles palais et églises que l'on peut découvrir de l'intérieur lorsque les portails sont ouverts. Les week-ends offrent les meilleurs moments pour s'y promener car la circulation est réduite.

Più di 500 anni fa, Papa Giulio II decise di costruire una strada tra il Vaticano e il centro cittadino – desiderio che Donato Bramante trasformò in realtà. Nacque così Via Giulia, la prima strada dritta di Roma, lunga 1 km. Ai suoi lati si susseguono vari tesori architettonici: chiese e palazzi nobiliari che talora – se i portali sono aperti – si possono visitare anche all'interno. Una splendida passeggiata che merita fare soprattutto nel fine settimana, quando c'è meno traffico.

VIA GIULIA

Centro Storico

Bus 116 Monserrato / Piazza Farnese

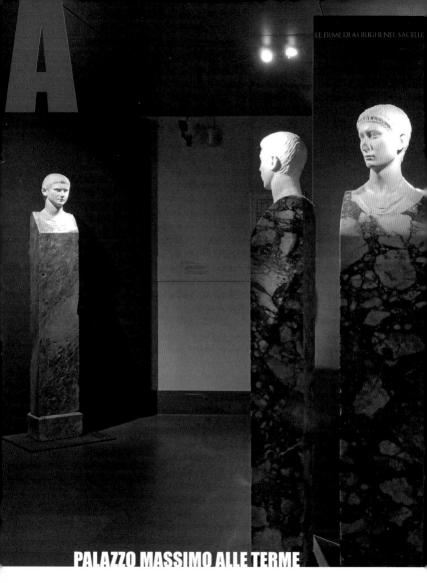

PALAZZO MASSIMO ALLE TERME

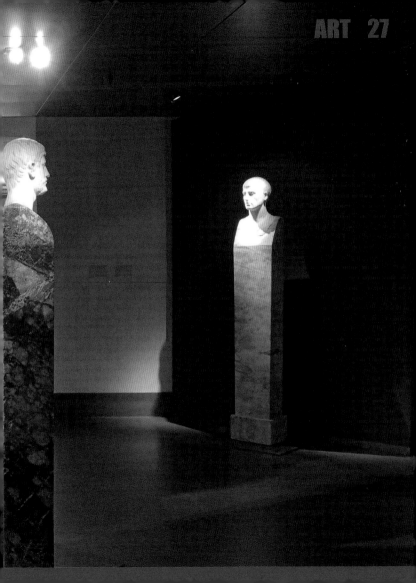

A

The archeological collection of the National Museum of Rome is among the most significant of its kind in the world, and the Palazzo Massimo is probably the most beautiful of the four museum locations. Four levels display coins and statues from the late Roman Republic and the early imperial period. Particularly stunning are the frescoes, including the garden hall from Villa di Livia, or the colorfully painted and stuccoed bedroom from Villa della Farnesina.

Die archäologische Sammlung des Museo Nazionale Romano zählt zu den bedeutendsten weltweit und der Palazzo Massimo ist wahrscheinlich der schönste der insgesamt vier Standorte des Museums. Auf vier Stockwerken werden Münzen und Statuen aus der Zeit der späten Römischen Republik und der frühen Kaiserzeit gezeigt. Ein besonderer Genuss sind die Wandmalereien, darunter der Gartensaal aus der Villa di Livia oder die bunt bemalten und mit Stuck verzierten Schlafzimmer aus der Villa della Farnesina.

La collection archéologique du Musée National Romain compte parmi les plus importantes au monde et le Palais Massimo est sans doute le plus beau des quatre sites du musée. Sur une surface de quatre étages sont exposées des pièces de monnaie et statues de la fin de la République Romaine et du début de l'Empire. Les visiteurs peuvent y admirer les peintures murales, dont celles de la salle aux jardins de la Villa di Livia ou les chambres colorées et ornées de stuc de la Villa della Farnesina.

La collezione di archeologia del Museo Nazionale Romano è una delle più prestigiose al mondo, e Palazzo Massimo è probabilmente la più bella delle quattro sedi complessive del museo. Su quattro piani vengono esposte monete e statue di epoca tardo-repubblicana e del primo periodo imperiale. Spiccano in particolare gli affreschi, come la pittura del giardino della Villa di Livia o la camera da letto di Villa della Farnesina, decorata con tonalità vivaci e impreziosita da stucchi.

PALAZZO MASSIMO ALLE TERME

Largo di Villa Peretti // Esquilino
Tel.: +39 06 39 96 77 00
archeoroma.beniculturali.it/musei/
museo-nazionale-romano-palazzo-massimo

Tue–Sun 9 am to 7.45 pm
Metro A and B Termini

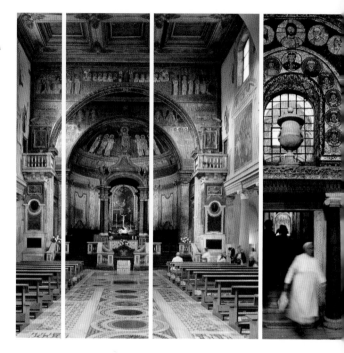

SANTA PRASSEDE

Via di Santa Prassede // Esquilino

Daily 7.30 am to noon
and 4 pm to 6.30 pm
Metro A and B Termini
Bus 70 Santa Maria Maggiore

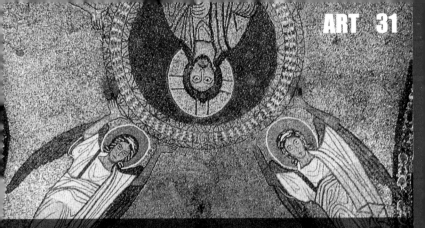

Tucked away not far from the Papal Basilica of Santa Maria Maggiore is the early medieval church of Santa Prassede, dedicated to a senator's daughter believed to have given shelter to the Apostle Peter. The church contains significant works of early Christian and medieval art. Be sure to have a look at the amazing mosaics covering the apse, the triumphal arch, and the Chapel of St. Zeno. Described at the time as the "gardens of paradise," these shimmering gold mosaics are Rome's most important Byzantine monument.

Nahe der Papstkirche Santa Maria Maggiore liegt etwas versteckt die frühmittelalterliche Kirche Santa Prassede – der Tochter eines Senators geweiht, der den Apostel Petrus beherbergt haben soll. Die Kirche enthält bedeutende Werke frühchristlicher und mittelalterlicher Kunst. Ein besonderes Juwel sind die Mosaiken der Apsis, des Triumphbogens und der Zenon-Kapelle. Deren golden schimmernden Mosaiken sind das wichtigste byzantinische Denkmal Roms, das zu jener Zeit als „Garten des Paradieses" bezeichnet wurde.

La basilique Sainte-Praxède, qui se situe à proximité de l'église papale du Haut Moyen-âge Santa Maria Maggiore, dédiée à la fille d'un sénateur, abrite la tombe de l'apôtre Pierre. On y trouve des œuvres d'art de l'Église primitive et moyenâgeux. Les mosaïques d'or scintillantes de l'abside, l'arc de triomphe et la chapelle de Zénon en constituent le joyau et font de ce mémorial byzantin le plus important de Rome ; à l'époque, il était caractérisé comme « le Jardin du Paradis ».

Vicino alla Basilica Santa Maria Maggiore sorge un po' nascosta la Chiesa di Santa Prassede, un edificio dell'Alto Medioevo consacrato alla figlia di un senatore che avrebbe dato accoglienza all'apostolo Pietro. Tra le sue importanti opere d'arte paleocristiana e medievale spiccano i mosaici dell'abside, dell'arco trionfale e della cappella di S. Zenone, in passato denominata "Giardino del Paradiso" per i ricchi mosaici dorati che ne fanno il più grande esempio di arte bizantina a Roma.

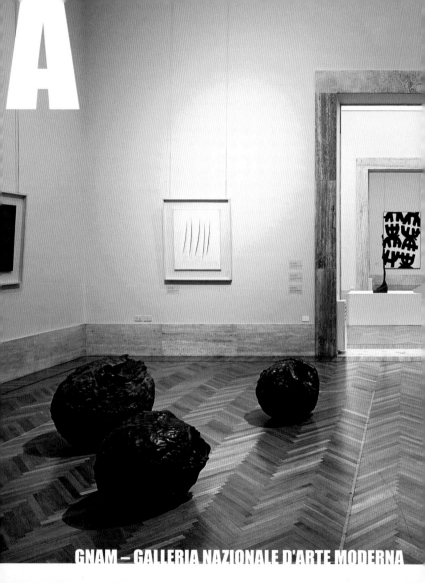

GNAM – GALLERIA NAZIONALE D'ARTE MODERNA

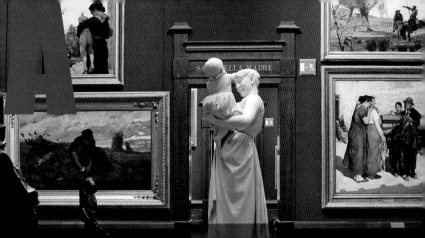

The 1911 construction of the Palazzo delle Belle Arti on the edge of the Villa Borghese celebrated the 50th anniversary of the unification of Italy. Several years later, works from some of the greatest painters and sculptors of the 19th and 20th centuries were moved into the National Gallery of Modern and Contemporary Art, among them the sculpture "Hercules and Lica" by Antonio Canova. The gallery also exhibits paintings from international artists such as Mondrian, Courbet, Van Gogh, Cézanne, Monet, Klee and Pollock.

Mit dem Bau des Palazzo delle Belle Arti am Rand der Villa Borghese sollte 1911 das 50-jährige Bestehen der Einheit Italiens gefeiert werden. Einige Jahre später zogen Werke der bedeutendsten italienischen Maler und Bildhauer des 19. und 20. Jahrhunderts in die Galleria Nazionale d'Arte Moderna, darunter die Skulptur „Herkules und Lica" von Antonio Canova. Zudem zeigt die Galerie einige Gemälde von ausländischen Künstlern wie Mondrian, Courbet, Van Gogh, Cézanne, Monet, Klee und Pollock.

Le cinquantenaire de l'unité italienne fut commémoré en 1911 avec la construction du Palazzo delle Belle Arti au bord de la Villa Borghese. Quelques années plus tard, la Galerie nationale d'art moderne accueillit les œuvres des plus importants peintres et sculpteurs du 19e et 20e siècle, dont la sculpture « Hercule et Lica » d'Antonio Canova. On peut également y admirer des peintures d'artistes étrangers tels que Mondrian, Courbet, Van Gogh, Cézanne, Monet, Klee et Pollock.

Il Palazzo delle Belle Arti ai margini di Villa Borghese fu costruito nel 1911 in occasione del 50° anniversario dell'Unità d'Italia. Qualche anno dopo le opere dei più importanti pittori e scultori italiani del XIX e XX secolo furono trasferite nella Galleria d'Arte Moderna, compreso il gruppo scultoreo "Ercole e Lica" di Antonio Canova. La galleria ospita anche dipinti di artisti di altra nazionalità quali Mondrian, Courbet, Van Gogh, Cézanne, Monet, Klee e Pollock.

GNAM – GALLERIA NAZIONALE D'ARTE MODERNA

Viale delle Belle Arti 131 // Flaminio
Tel.: +39 06 32 29 81
www.gnam.beniculturali.it

Tue–Sun 8.30 am to 7.30 pm
Tram 3 and 19 Galleria Arte Moderna

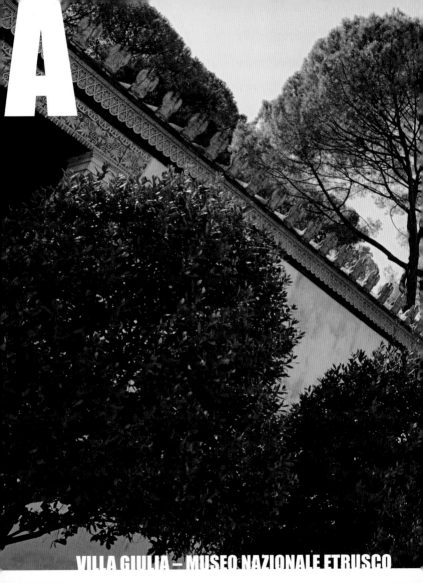

A

VILLA GIULIA – MUSEO NAZIONALE ETRUSCO

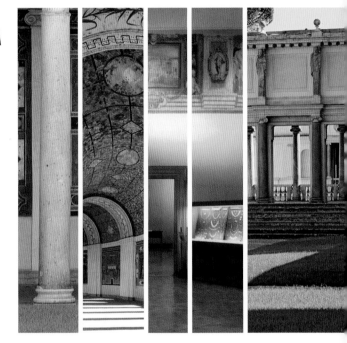

VILLA GIULIA –
MUSEO NAZIONALE ETRUSCO

Piazzale di Villa Giulia 9 // Flaminio
Tel.: +39 06 32 26 57 1

Tue–Sun 8.30 am to 7.30 pm
Tram 19 Museo Etrusco Villa Giulia

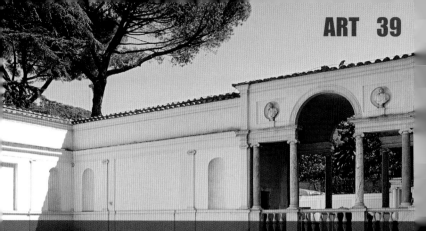

Former 16th century summer residence of Pope Julius III, the Villa Giulia now houses the most significant collection of Etruscan art anywhere. Though little is known about the Etruscans who settled primarily in Tuscany in the 8th century, numerous recent discoveries have thrown light on their civilization. One of the exhibition highlights is the Sarcophagus of the Spouses from Cerveteri. Visitors will also delight in the numerous frescoes to be found in the Villa's inner courtyards.

Die Sammlung der Villa Giulia, der ehemaligen Sommerresidenz Papst Julius' III. im 16. Jahrhundert, beherbergt die bedeutendste Sammlung etruskischer Kunst überhaupt. Man weiß gar nicht viel über dieses Volk, das bereits im 8. Jahrhundert vor allem in der heutigen Toskana siedelte, doch haben zahlreiche Funde mittlerweile das Bild von den Etruskern geschärft. Eines der Highlights der Ausstellung ist der Ehegattensarkophag aus Cerveteri. In den Innenhöfen erfreuen zahlreiche Fresken die Augen der Besucher.

La collection de la Villa Giulia, ancienne résidence d'été du Pape Jules III au 16e siècle, abrite les plus importantes œuvres d'art étrusque. L'histoire de ce peuple, établi au 8e siècle sur le territoire actuel de Toscane, est restée longtemps méconnue, mais depuis les dernières découvertes, on a appris à mieux le connaître. Le sarcophage des époux de Cerveteri est la pièce majeure de l'exposition. Les cours intérieures dévoilent des fresques admirées par les visiteurs.

Le opere d'arte di Villa Giulia, che nel XVI secolo fu la residenza estiva di Papa Giulio III, comprendono la più grande collezione d'arte etrusca del mondo. Non si sa molto di questa civiltà stabilitasi soprattutto nell'odierna Toscana già nell'VIII secolo, ma i numerosi reperti rinvenuti ne hanno delineato un'immagine abbastanza chiara. Tra tutti spicca il Sarcofago degli Sposi, ritrovato a Cerveteri. Incantevoli anche i numerosi affreschi che adornano i cortili interni del palazzo.

San Clemente displays the vestiges of history in a single building: at the lowest level an excavated apartment building with a Temple of Mithras; above that the lower church dating from the 4th century; and at the top level you can visit the upper church from the 12th century. You enter through a front courtyard with a beautiful fountain where summer concerts are held. Finely crafted mosaics adorn the triumphal arch and apse, and marble inlays decorate the interior.

In San Clemente werden die Spuren der Geschichte in einem einzigen Gebäude sichtbar: Im Untergeschoss befindet sich ein freigelegtes Wohnhaus mit einem Mithras-Heiligtum; darüber die Unterkirche aus dem 4. und schließlich die Oberkirche aus dem 12. Jahrhundert. Man betritt sie durch einen Vorhof mit hübscher Brunnenanlage, in dem im Sommer Konzerte stattfinden. Fein gearbeitete Mosaiken auf Triumphbogen und Apsis sowie zahlreiche Marmorintarsien schmücken das Innere.

La basilique Saint-Clément porte les marques de l'histoire. Au sous-sol est situé un espace voûté avec un sanctuaire dédié à Mithra. L'église actuelle fut construite au 12e siècle sur les fondations d'une église souterraine datant du 4e siècle. On y pénètre en traversant l'avant-cour qui est dotée d'une jolie fontaine, et accueille des concerts en été. L'intérieur est composé d'arcs de triomphe et d'une apside revêtus de mosaïques ouvragées ainsi que de marqueteries de marbre.

Nella Basilica di San Clemente si possono ripercorrere le orme della storia andando per ordine: al livello più basso si trova un'abitazione indipendente con un Mitreo; sopra si erge la basilica inferiore del IV secolo, cui segue la basilica superiore del XII. Si accede alla basilica da un cortile anteriore abbellito da una fontana, dove d'estate si tengono concerti. Mosaici di fine fattura visibili sull'arco trionfale e sull'abside e numerosi intarsi marmorei ne adornano l'interno.

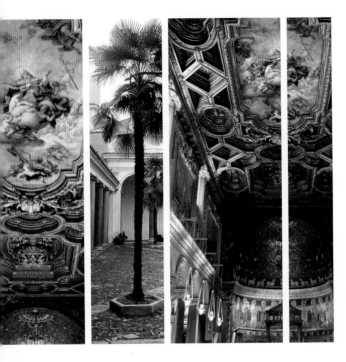

SAN CLEMENTE

Via Labicana 95 // Laterano
Tel.: +39 06 77 40 02 1
www.basilicasanclemente.com

Mon–Sat 9 am to 12.30 am and
3 pm to 6 pm, Sun noon to 6 pm
Metro B Colosseo

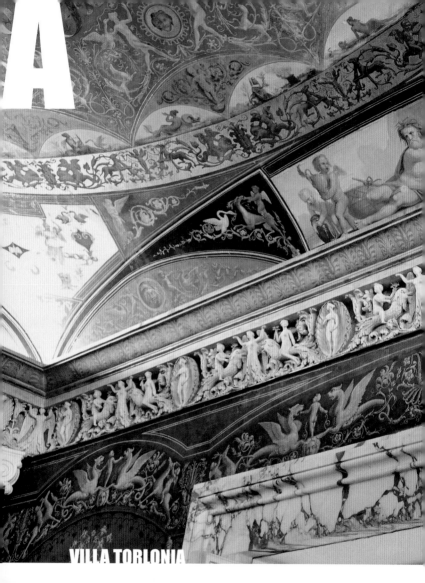

A

VILLA TORLONIA

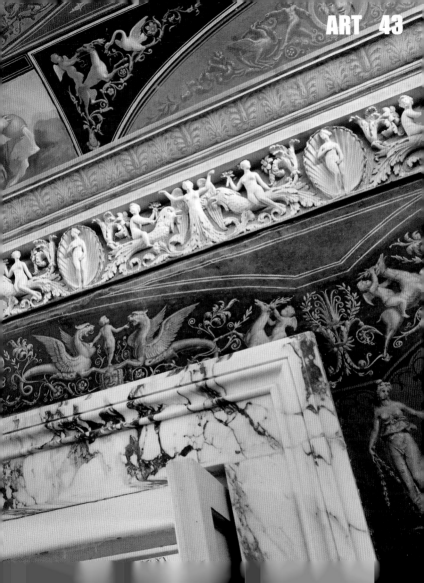

VILLA TORLONIA

Via Nomentana 70 // Nomentano
Tel.: +39 06 06 08
www.museivillatorlonia.it

Tue–Sun 9 am to 7 pm
Bus 36 Nomentana / Trieste
Bus 84 Nomentana / Villa Paganini

Casino Nobile in the charming park of Villa Torlonia was restored in 2006 and has been open to the public since then. Built by Giuseppe Valadier in 1802, Villa Torlonia is a worthwhile destination not only because of its neoclassical pieces but also because of the building itself, which offers stunning frescoes and luxurious decorations. In the 20th century, the Villa's best known tenant was Benito Mussolini; his bed is still in one of the bedrooms.

Das Casino Nobile im reizenden Park der Villa Torlonia ist seit 2006 restauriert und der Öffentlichkeit zugänglich. Die 1802 von Giuseppe Valadier gebaute Villa lohnt nicht nur wegen ihrer vorwiegend neoklassizistischen Exponate, sondern auch wegen des Hauses selbst, das mit überwältigenden Fresken und luxuriöser Dekoration aufwartet. Der bekannteste Mieter der Villa im 20. Jahrhundert war Benito Mussolini — sein Bett steht noch heute in einem der Schlafzimmer.

Le Casino Nobile situé dans le magnifique parc de la Villa Torlonia fut rénové et ouvert au public en 2006. La villa construite en 1802 par Giuseppe Valadier est non seulement un chef d'œuvre du style néoclassique mais présente également de magnifiques fresques et des décorations luxurieuses. Son locataire le plus connu au XXe siècle n'est autre que Benito Mussolini, dont le lit est toujours présent dans l'une des chambres.

Il Casino Nobile, nel delizioso parco di Villa Torlonia, è stato ristrutturato e aperto al pubblico nel 2006. La villa, eretta nel 1802 da Giuseppe Valadier, merita una visita non solo per le sue esposizioni, a tema prevalentemente neoclassico, ma anche per l'edificio in sé, che incanta con i suoi sorprendenti affreschi e le lussuose decorazioni. L'inquilino più famoso che la villa ospitò nel XX secolo fu Benito Mussolini, il cui letto è visibile ancora

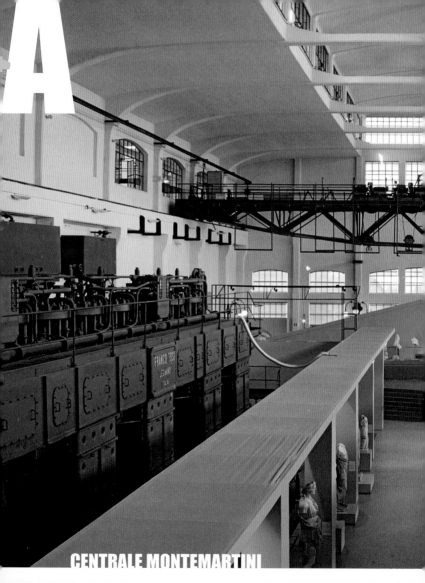

A

CENTRALE MONTEMARTINI

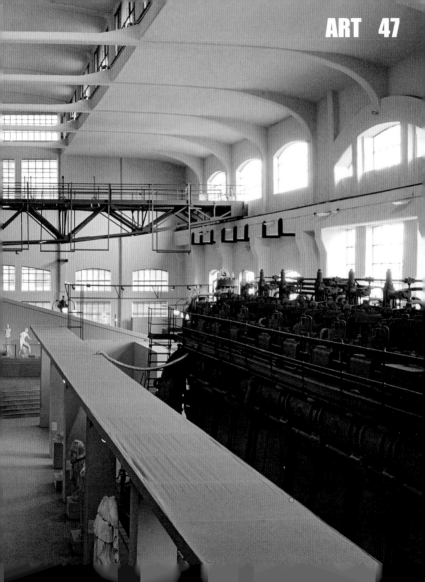

Built in 1912 as an electrical power plant for the Ostiense district, the Centrale Montemartini was originally thought of as a temporary solution to house the collection of the Capitoline Museums. Yet after ten years, it has secured a fixed spot in the Roman museum landscape. Huge machines, motors, and steel girders form the backdrop for statues, busts, reliefs, and mosaics from ancient Rome, the majority of which were discovered towards the end of the 19th century.

Eigentlich war die Centrale Montemartini, das ehemalige Elektrizitätswerk im Stadtteil Ostiense aus dem Jahr 1912, als Provisorium für die Sammlung der Kapitolinischen Museen gedacht. Doch nach über zehn Jahren hat sie sich einen festen Platz in der römischen Museumslandschaft gesichert. Riesige Maschinen und Motoren sowie Stahlkonstruktionen bilden die Kulisse für Statuen, Büsten, Reliefs und Mosaiken aus dem antiken Rom, die vor allem gegen Ende des 19. Jahrhunderts gefunden wurden.

L'ancienne centrale électrique de Montemartini, datant de 1912 et située dans le quartier Ostiense, devait servir de lieu d'exposition provisoire à la collection des musées du Capitole. Au bout de dix ans, elle devint l'un des musées les plus connus à Rome. D'immenses machines et moteurs ainsi que des constructions en acier forgent les coulisses de ce musée original où sont exposés statues, bustes, reliefs et mosaïques de la Rome Antique découverts à la fin du 19e siècle.

Ospitata nella ex centrale termoelettrica costruita nel 1912 nel quartiere di Ostiense, la Centrale Montemartini fu originariamente concepita come sede provvisoria per la collezione dei Musei Capitolini, ma dopo oltre un decennio si è assicurata un posto stabile nel panorama dei musei di Roma. Enormi macchine e motori e strutture in acciaio fanno da cornice a statue, busti, rilievi e mosaici dell'antica Roma, opere rinvenute prevalentemente verso la fine del XIX secolo.

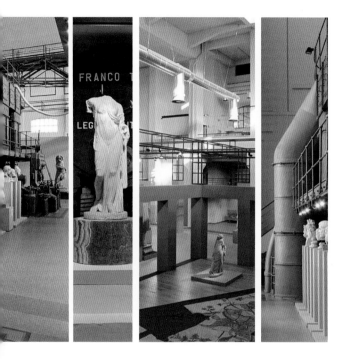

CENTRALE MONTEMARTINI

Via Ostiense 106 // Ostiense
Tel.: +39 06 06 08
www.centralemontemartini.org

Tue–Sun 9 am to 7 pm
Metro B Garbatella

MACRO

Via Nizza 138/angolo Via Cagliari // Salario
Tel.: +39 06 06 08
www.macro.roma.museum

Tue–Sun 11 am to 10 pm
Bus 38 Nizza / Viale Regina Margherita

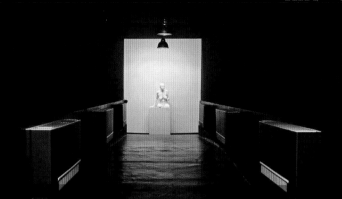

MACRO has two locations: its traditional home in the former buildings of beer brewery Peroni in the Salario district, recently expanded with an addition designed by French architect Odile Decq, and in a former slaughterhouse from the 19th century in the Testaccio district. Both MACRO locations show contemporary Italian and international art. In addition to works from its own permanent collections, MACRO also presents alternating exhibitions.

Das MACRO befindet sich an zwei Standorten: traditionell in den früheren Gebäuden der Bierbrauerei Peroni im Viertel Salario, die kürzlich um einen Anbau der französischen Architektin Odile Decq erweitert wurden, sowie im Viertel Testaccio, in einem ehemaligen Schlachthof aus dem 19. Jahrhundert. An beiden Standorten präsentiert es zeitgenössische italienische und internationale Kunst. Neben der thematisch aufgebauten Sammlung finden regelmäßig Wechselausstellungen statt.

Le MACRO s'étend sur deux sites distincts : le site traditionnel, auquel on a récemment ajouté une annexe conçue par l'architecte française Odile Decq, situé dans les bâtiments de l'ancienne brasserie Peroni du quartier Salario, et le second localisé dans un ancien abattoir du XIXe siècle dans le quartier Testaccio. Des œuvres d'art contemporain italien et international y sont exposées. Des expositions temporaires régulières complètent le programme de la collection permanente.

Il MACRO possiede due sedi: quella originaria ospitata negli ex edifici della fabbrica di birra Peroni nel rione di Salario che ampliata di recente con un'ala progettata dall'architetto francese Odile Decq, e quella di Testaccio, ricavata da un ex mattatoio del XIX secolo. Entrambe le sedi espongono opere d'arte contemporanea italiana e internazionale. Accanto alla collezione tematica del museo, vi hanno luogo regolarmente anche mostre temporanee.

ROBERTO CASIR

Roberto Casiraghi, born in Genoa in 1953, was the director of the Turin art fair Artissima for thirteen years before he embarked on new adventures: first a fair in Milan focusing on antiques and modern art; then a fair on contemporary art in Rome, called The Road to Contemporary Art. The first fair in Rome took place in 2008 and was an instant success—not least because of Casiraghi's decision to present contemporary art in historic buildings in the city center and in the former slaughterhouse in the Testaccio district instead of in boring halls typical for most fairs. In addition, Casiraghi, who has a business degree and originally entered the world of galleries, exhibitions and hence art by selling advertising, was able to pull off another coup: He talked Roman collectors into making their pieces available for viewing by interested visitors. In Turin, it took him years to achieve this, says Casiraghi. In Rome, he succeeded right away.

Dreizehn Jahre lang betreute der 1953 in Genua geborene Roberto Casiraghi die Turiner Kunstmesse Artissima, bevor er sich in ein neues Abenteuer stürzte: erst eine Messe in Mailand zu Antiquitäten und moderner Kunst, dann eine Messe zur Zeitgenössischen Kunst in Rom, The Road to Contemporary Art genannt. 2008 fand die erste Ausgabe statt und war gleich ein Erfolg – schon wegen Casiraghis Idee, die zeitgenössische Kunst nicht wie sonst bei Messen oft üblich in langweiligen Hallen, sondern in historischen Gebäuden im Stadtzentrum und im ehemaligen Schlachthof im Viertel Testaccio zu präsentieren. Zudem gelang dem studierten Kaufmann Casiraghi, der einst über den Verkauf von Werbung in Kontakt mit Galerien und Ausstellungen und damit zur Kunst kam, ein weiterer Coup: Er brachte römische Sammler dazu, ihre Werke ausnahmsweise für interessierte Besucher zugänglich zu machen. Für dieses Ergebnis habe er in Turin Jahre gebraucht, so Casiraghi. In Rom gelang es ihm sofort.

AGHI

Roberto Casiraghi, né en 1953 à Gênes, dirigea pendant treize ans le salon d'art Artissima de Turin avant de vivre une nouvelle aventure, qui le conduisit d'abord au salon des antiquités et de l'art moderne de Milan et ensuite au salon d'art contemporain de Rome, connu sous le nom de The Road to Contemporary Art. L'idée de Casiraghi d'exposer des œuvres d'art contemporain dans des édifices historiques du centre et dans les anciens abattoirs du quartier de Testaccio, au lieu d'opter pour le décor ennuyeux des grands halls habituels, contribua fortement au succès de ce salon ouvert en 2008. Ce commercial de formation vendait autrefois de la publicité aux galeries et sites d'exposition, ce qui lui permit de faire son entrée dans le monde de l'art. D'un coup de maître, il amena des collectionneurs romains à partager leurs trésors avec un public intéressé. À Rome, la tâche s'avéra plus facile qu'à Turin, où il dut attendre une éternité avant de parvenir à son but.

Nato a Genova nel 1953, Roberto Casiraghi è stato per tredici anni direttore della fiera d'arte Artissima di Torino prima di avventurarsi in un nuovo progetto: prima la mostra mercato d'antiquariato e arte moderna di Milano, poi la fiera d'arte contemporanea The Road to Contemporary Art di Roma. La prima edizione della fiera si svolse nel 2008 e fu subito un successo − a partire dall'idea di Casiraghi di presentare le opere non nei tipici padiglioni anonimi delle fiere, bensì in edifici storici del centro di Roma e nell'ex mattatoio del rione di Testaccio. A Casiraghi, laureato in economia e commercio e venuto a contatto con il mondo dell'arte grazie alla vendita di materiale pubblicitario pensato per gallerie ed esposizioni di opere artistiche, si deve anche un altro merito: quello di aver convinto alcuni collezionisti romani ad esporre in via eccezionale le proprie opere a un pubblico di appassionati. Traguardo che a Torino Casiraghi ha potuto raggiungere solo dopo diversi anni di lavoro. A Roma ci è riuscito subito.

The Studio d'Arte Contemporanea Pino Casagrande has been around since 1991, but it didn't move into the former pasta factory in the lively city district of San Lorenzo until 1995. The building teems with creative tenants, including photography and artist studios. On the top floor, the gallery shows a preference for minimalistic and concept art; in past years, exhibitions have included artists Jirì Kolàr, Ange Leccia, Thomas Ruff, and Michelangelo Pistoletto.

Bereits seit 1991 gibt es schon das Studio d'Arte Contemporanea Pino Casagrande, aber erst 1995 zog es in die ehemalige Pastafabrik im lebendigen Stadtteil San Lorenzo. Das Gebäude strotzt vor kreativen Mietern, darunter Fotostudios und Künstlerateliers. Im obersten Stockwerk bekundet die Galerie eine Präferenz für minimalistische und Konzeptkunst. In den vergangenen Jahren haben unter anderen Jirì Kolàr, Ange Leccia, Thomas Ruff und Michelangelo Pistoletto hier ausgestellt.

Le Studio d'Arte Contemporanea Pino Casagrande existe depuis 1991, mais n'a élu domicile dans l'ancienne usine de pâtes du quartier vivant de San Lorenzo qu'en 1995. L'édifice est essentiellement occupé par des locataires créatifs - studios photos et ateliers d'artistes. La galerie du dernier étage manifeste une préférence pour l'art minimaliste et conceptuel. Des artistes tels que Jirì Kolàr, Ange Leccia, Thomas Ruff et Michelangelo Pistoletto y ont exposé leurs œuvres.

Fondato già nel 1991, lo Studio d'Arte Contemporanea Pino Casagrande si è trasferito in un ex pastificio nel vivace quartiere di San Lorenzo solo nel 1995. Sono molti i creativi che occupano l'edificio, come ad esempio studi fotografici e atelier artistici. Al piano superiore la galleria mostra una preferenza per l'arte minimalista e concettuale. Negli anni passati anche Jirì Kolàr, Ange Leccia, Thomas Ruff e Michelangelo Pistoletto hanno organizzato qui le loro mostre.

GALLERIA PINO CASAGRANDE

Via degli Ausoni 7 A // San Lorenzo
Tel.: +39 06 44 63 48 0

Mon–Fri 5 pm to 8 pm
Tram 3 or Tram 19 Reti
Bus 163 Verano

At the end of the 19th century, Professor Emanuel Löwy began to build a "plaster museum" for study purposes. It consisted of plaster statues of Greek originals and Roman copies. In the 1930s, this collection was transferred to the newly constructed Sapienza University of Rome since other locations had become too small. Today, the museum has about 1,200 plaster statues, which are presented chronologically and students can be found amongst the statues, reading books.

Bereits Ende des 19. Jahrhunderts begann der Professor Emanuel Löwy zu Studienzwecken mit dem Aufbau des „Gipsmuseums", bestehend aus Gipsfiguren griechischer Originale und römischer Kopien. Seit den 30er-Jahren hat es seinen Platz in der damals neu gebauten Universität La Sapienza, da andere Räumlichkeiten zu klein geworden waren. Heute besitzt das Museum rund 1 200 Gipsfiguren, die chronologisch präsentiert werden, und zwischen denen die Studenten sich in ihre Bücher vertiefen.

À la fin du XIXe siècle, le professeur Emanuel Löwy mit sur pied, à des fins universitaires, le « musée du plâtre » regroupant des figures de plâtre, dont des originaux grecs et des copies romaines. Depuis les années 1930, le musée occupe des salles de l'Université La Sapienza, qui venait d'être bâtie à cette époque. De nos jours, 1 200 figures de plâtre y sont exposées et classées chronologiquement. Les étudiants parcourent leurs livres dans ce décor pour le moins original.

A fine del XIX secolo il Professor Emanuel Löwy avviò a scopi didattici la costruzione del "Museo dei Gessi", comprendente calchi in gesso di originali greci e copie romane. Dagli anni 1930 scorso il museo ha sede nell'allora nuova Università La Sapienza, poiché le altre ubicazioni erano diventate troppo piccole. Oggi vanta circa 1 200 calchi, presentati in ordine cronologico, in mezzo ai quali gli studenti si immergono nella lettura dei loro libri.

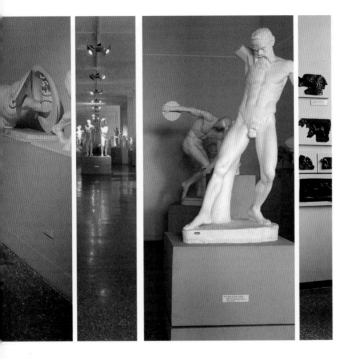

MUSEO DELL'ARTE CLASSICA

Università degli Studi di Roma „La Sapienza"
Piazzale Aldo Moro 5 // San Lorenzo
Tel.: +39 06 49 91 39 60

Mon–Fri 9 am to 5 pm
Metro B Policlinico

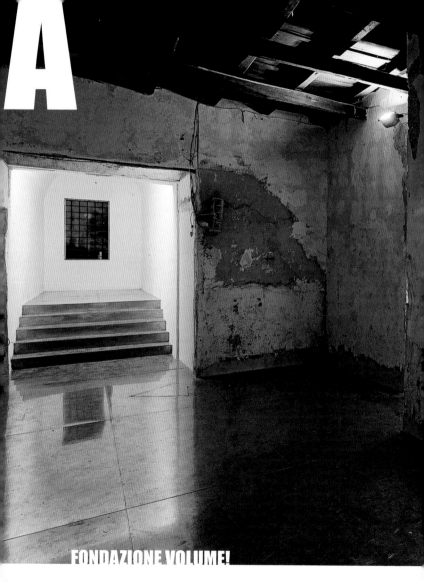

A

FONDAZIONE VOLUME!

A

Fondazione Volume! was founded in 1997 with the goal of promoting culture as a public asset while also creating a connection between art and other areas. For instance, students from different disciplines are invited to participate in discussions with artists from Italy and around the world. Since its inception, the foundation has exhibited works of over 60 artists and architects and has now begun to include music as well.

Die Fondazione Volume! wurde 1997 mit dem Ziel gegründet, Kultur als öffentliches Gut zu erhalten und gleichzeitig eine Verbindung zwischen Kunst und anderen Bereichen zu schaffen. Deshalb werden unter anderem Studenten verschiedener Fachrichtungen eingeladen, mit den italienischen und ausländischen Künstlern zu diskutieren. Seit ihrer Gründung hat die Stiftung die Werke von über 60 Künstlern und Architekten ausgestellt und wagt sich nun auch in den Bereich der Musik vor.

La Fondazione Volume! fut créée en 1997 avec pour objectif de maintenir la culture pour tous et combiner l'art à d'autres domaines. En ce sens, des étudiants de différentes disciplines sont conviés pour s'entretenir avec des artistes étrangers et italiens. Depuis son ouverture, la fondation a exposé les travaux de plus de 60 artistes et architectes et ose s'aventurer dans le domaine musical.

La Fondazione Volume! è stata creata nel 1997 con lo scopo di rendere la cultura accessibile a tutti, stabilendo al contempo un collegamento tra l'arte e le altre discipline. E per questo che alle discussioni con artisti italiani e stranieri vengono invitati, tra gli altri, studenti di diverse facoltà. Dalla sua fondazione sono stati ben 60 i lavori di artisti e architetti esposti nei locali dell'associazione che adesso si avventura anche nel campo della musica.

FONDAZIONE VOLUME!

Via San Francesco di Sales 86/88 // Trastevere
Tel.: +39 06 68 92 43 1
www.fondazionevolume.com

Tue–Fri 5 pm to 7.30 pm
Bus 280 LGT Farnesina

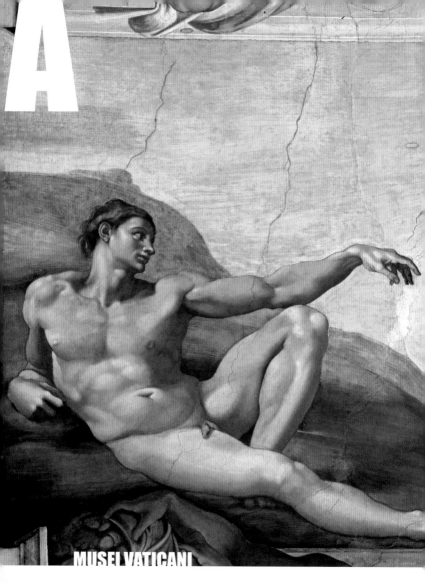

A

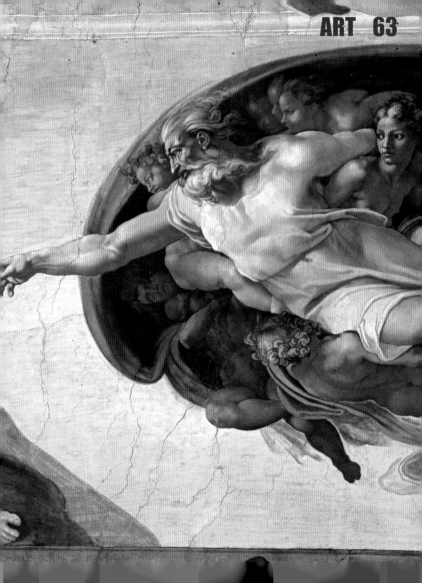

MUSEI VATICANI

Viale Vaticano // Vaticano
Tel.: +39 06 69 88 46 76

Mon–Sat 9 am to 6 pm, entrance until 4 pm
Metro A Cipro-Musei Vaticani
Tram 19 Piazza del Risorgimento

With 4 miles of gallery aisles, the Vatican Museums are among the largest museums in the world. You can spend days there without seeing all of their treasures. Must-see attractions include the Sistine Chapel, inseparably linked to Michelangelo, and Raphael's Rooms. Particularly remarkable is his School of Athens in the Stanza della Segnatura. The maps of the various regions of Italy are of significant documentary value.

Die Vatikanischen Museen mit ihrem 7 km langen Rundgang gehören zu den größten Museen der Welt, und man kann Tage darin verbringen, ohne alle Schätze gesehen zu haben. Nicht entgehen lassen sollte man sich die Sixtinische Kapelle, die untrennbar mit dem Namen Michelangelos verbunden ist, sowie die Stanzen von Raffael. Besonders bemerkenswert ist seine Schule von Athen in der Stanza della Segnatura, von hohem dokumentarischen Wert sind zudem die Landkarten der Regionen Italiens.

Les musées du Vatican, avec leurs 7 km de promenade, comptent parmi les plus grands musées au monde. On peut y passer des journées entières sans parvenir à admirer tous les trésors. Il faut absolument voir la Chapelle Sixtine, chef d'œuvre du grand Michel-Ange, et les Chambres de Raphaël. L'Ecole d'Athènes de la Stanza della Segnatura, où sont exposées les cartes des régions italiennes d'une grande valeur documentaire, vaut aussi le détour.

Con uno spazio adibito a passaggio lungo ben 7 km, i Musei Vaticani figurano tra i più grandi musei al mondo: vi si possono trascorrere giorni interi senza aver visto tutti i tesori che custodiscono. Imperdibile la Cappella Sisitina, legata in modo indissolubile al nome di Michelangelo, come pure le Stanze di Raffaello, in cui spicca soprattutto La Scuola di Atene ospitata nella Stanza della Segnatura. Di grande valore storico sono anche le cartine geografiche delle regioni d'Italia.

A

From the Colosseum built in the 1st century AD—the best-known Roman icon of all—to the Zaha Hadid-designed art museum MAXXI opened in 2010, Rome is studded with buildings and monuments worthy of closer exploration. That is what makes Rome so special. Since ancient times, the new was added to the old, the old was overlaid by the new, and buildings dating back to antiquity, like the Pantheon, were plundered to embellish a church like St. Peter's Basilica. In spite of this, very few modern buildings were constructed in the 20th century. This started to change a few years ago. Richard Meier designed a museum for the Ara Pacis, Renzo Piano built the Auditorium Parco della Musica, and Zaha Hadid unveiled her MAXXI. Other buildings by renowned architects like Massimiliano Fuksas are under construction. The architectural evolution of Rome still manages to keep us in thrall—may it continue like this for the next 2,000 years!

Vom Kolosseum aus dem 1. Jahrhundert n. Chr., das zu einem Symbol Roms geworden ist, bis zum 2010 eröffneten Museum MAXXI der Architektin Zaha Hadid gibt es eine Vielzahl an Gebäuden und Denkmälern, die einer eingehenden Beschreibung Wert sind. Gerade das macht den Reiz Roms aus. Immer schon kam Neues zum Alten dazu, wurde Altes durch Neues überlagert oder wurden antike Gebäude wie das Pantheon geschröpft, um damit eine Kirche wie den Petersdom auszuschmücken. Trotzdem schreckte die Stadt im 20. Jahrhundert lange vor dem Bau moderner Gebäude zurück. Seit ein paar Jahren ist das anders. Richard Meier entwarf ein Museum für die Ara Pacis, Renzo Piano erbaute das Auditorium Parco della Musica und Zaha Hadid ihr Museum. Weitere Gebäude namhafter Architekten wie Massimiliano Fuksas sind im Bau. Die architektonische Entwicklung Roms bleibt also spannend – hoffentlich auch für die nächsten 2 000 Jahre.

Le Colisée, symbole de Rome construit au Ier siècle après J.C. ou encore le musée MAXXI de l'architecte Zaha Hadid, inauguré en 2010, ne sont que quelques exemples des merveilles architecturales qui mériteraient une description approfondie. C'est justement cette richesse qui fait tout le charme de Rome. Depuis toujours, le moderne fut ajouté, greffé à l'ancien, voire embelli par celui-ci, comme ce fut le cas de la basilique Saint-Pierre qui se vit enrichie des trésors du Panthéon. Et pourtant, jusqu'au XXe siècle, la ville a toujours eu des réticences à innover complètement. Ce n'est plus le cas depuis quelques années : Richard Meier a conçu un musée pour l'Ara Pacis, Renzo Piano a construit l'Auditorium Parco della Musica et Zaha Hadid son musée. D'autres édifices d'illustres architectes tels que Massimiliano Fuksas sont en cours de construction. L'évolution architecturale de Rome a donc gardé tout son dynamisme, espérons que cela continue dans les 2 000 années à venir.

Dal Colosseo, simbolo della città di Roma risalente al I secolo d.C., al Museo MAXXI, progettato da Zaha Hadid e inaugurato nel 2010, sono molti gli edifici e i monumenti che meriterebbero una trattazione approfondita. È proprio qui che sta il fascino di Roma. Accanto a costruzioni vecchie sono sempre sorte altre nuove, parti antiche sono state sovrapposte da nuove e palazzi storici come il Pantheon defraudati per abbellire chiese come la Basilica di San Pietro. Eppure nel XX secolo la città si è opposta a lungo alla costruzione di edifici in stile moderno. Da un paio d'anni la situazione è cambiata. Richard Meier ha progettato un museo per l'Ara Pacis, Renzo Piano ha realizzato l'Auditorium Parco della Musica e Zaha Hadid il museo che oggi porta il suo nome. Altri edifici affidati ad architetti di spicco come Massimiliano Fuksas sono attualmente in costruzione. Lo sviluppo architettonico di Roma ha quindi in serbo piacevoli sorprese – si spera ancora per i prossimi 2 000 anni.

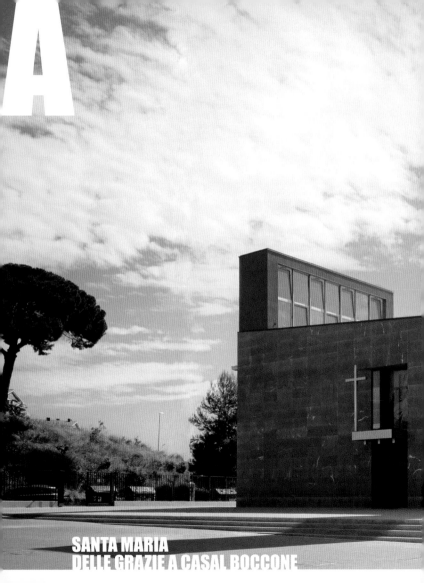

A

SANTA MARIA
DELLE GRAZIE A CASAL BOCCONE

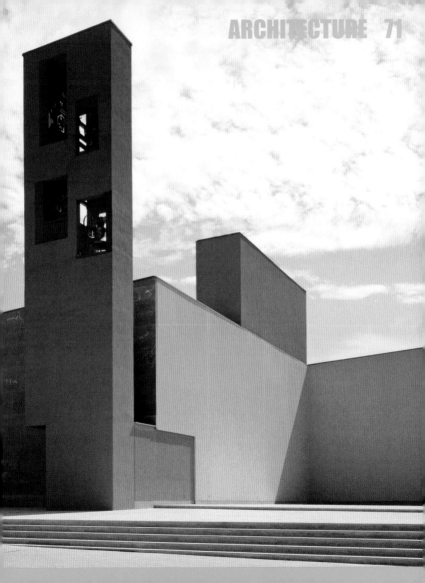

Dedicated in May 2010, the unique architecture of the church Santa Maria delle Grazie has put the Casal Boccone district on the map. Architectural firm Garofalo Miura created the striking post-modern design of this multi-level church and church hall, positioned on a hill like an acropolis. To enter, visitors pass through a forecourt with a clear view of the bell tower, which beckons believers from afar.

Im Mai 2010 wurde die Kirche Santa Maria delle Grazie in Casal Boccone geweiht und hat diesem Viertel damit zu einem architektonischen Highlight verholfen. Verantwortlich dafür ist das Architekturbüro Garofalo Miura, das die Kirche und ihren Gemeindesaal auf mehreren Etagen baute – die Anhöhe nutzend, auf der die Kirche sich ähnlich einer Akropolis befindet. Man betritt sie von einem Vorplatz aus – den vorgezogenen Kirchturm im Blick, der für die Gläubiger wie ein Signal wirken soll.

Inaugurée en mai 2010, l'église Sainte-Marie-des-Grâces a fait du quartier de Casal Boccone un repère d'architecture incontournable. En adaptant la construction de l'église et de la paroisse au relief élevé, le tout rappelant une acropole, le bureau d'architecture Garofalo Miura a accompli un travail magnifique sur plusieurs étages. L'entrée se fait par un parvis et est dominée par le clocher qui rappelle l'importance de la foi aux fidèles.

Con la consacrazione della chiesa di Santa Maria delle Grazie a maggio 2010, il quartiere di Casal Boccone è divenuto un punto di attrazione per gli appassionati di architettura. Lo studio di architettura Garofalo Miura ha costruito una chiesa e una sala parrocchiale su più piani, sfruttando la collina su cui l'edificio si erge come un'acropoli. Accedendo alla chiesa dal sagrato, si ha proprio davanti a sé il campanile, che deve essere come un segnale per i fedeli.

SANTA MARIA
DELLE GRAZIE A CASAL BOCCONE

Via della Bufalotta 674 // Casal Boccone
Tel.: +39 06 87 13 34 38
www.smdellegrazie.it

Daily 7.30 am to 8 pm
Tram 86 fermata Bufalotta / Settebagni

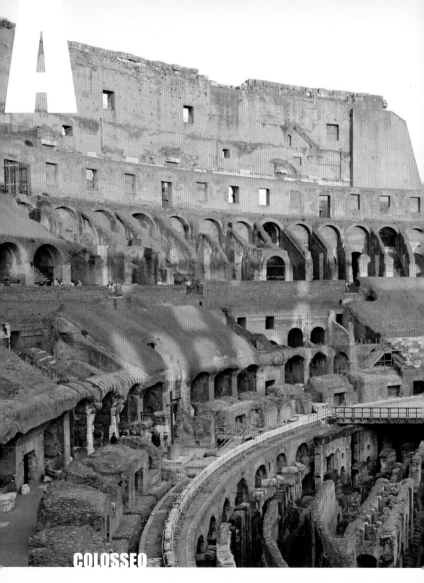

COLOSSEO

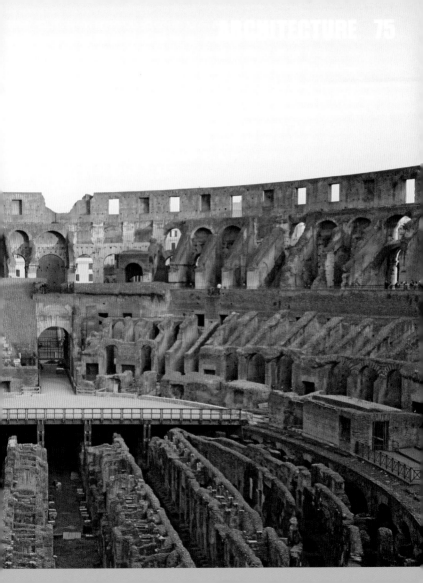

The Colosseum, dedicated in 80 AD under Emperor Titus, was a masterpiece of engineering: it could be flooded for mock sea battles, covered to protect spectators from the sun and, thanks to many well-positioned exits, evacuated in a matter of minutes. The interior of this Roman landmark is impressive for its tiered design, the subterranean tunnels and animal cages, and its immense size: the Colosseum could accommodate 50,000 people.

Das im Jahr 80 n. Chr. unter Kaiser Titus eingeweihte Kolosseum war ein Meisterwerk der Ingenieurskunst: Es konnte für Seeschlachten geflutet, zum Schutz vor Sonne überdacht, und – dank der zahlreichen und gut platzierten Ausgänge – innerhalb von Minuten geleert werden. Das Innere des römischen Wahrzeichens vermittelt einen Eindruck von seiner Bauweise, der unterirdischen Anlage der Raubtierkäfige sowie seiner unglaublichen Größe – 50 000 Menschen fanden darin Platz.

Le Colisée, inauguré en 80 après J.C. sous l'empereur Titus, est un chef d'œuvre d'ingénierie. Il pouvait être inondé pour simuler des batailles navales, couvert pour se protéger du soleil et être évacué en un rien de temps grâce aux nombreuses sorties bien placées. L'intérieur de ce symbole de Rome impressionne par sa construction, ses installations sous-terraines où se trouvaient les cages des fauves, et ses dimensions incroyables. Il accueillait jusqu'à 50 000 personnes.

Inaugurato nell'80 d.C. dall'Imperatore Tito, il Colosseo è un capolavoro dell'arte ingegneristica: poteva essere riempito d'acqua per ospitare battaglie navali, venir coperto per proteggere dal sole ed essere evacuato in pochi minuti grazie alle tante uscite collocate in punti strategici. L'interno permette di farsi un'idea delle tecniche edilizie adottate, della disposizione sotterranea delle gabbie per gli animali feroci e delle dimensioni della struttura, che poteva accogliere 50 000 persone.

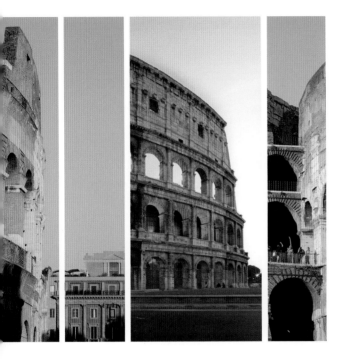

COLOSSEO

Piazza del Colosseo // Centro Storico
Tel.: +39 06 77 40 09 22
archeoroma.beniculturali.it/siti-archeologici/colosseo

Nov–Feb 8.30 am to 4.30 pm, Mar 8.30 am to 5.30 pm,
Apr–Aug 8.30 am to 7.15 pm,
Sep 8.30 am to 7 pm, Oct 8.30 am to 6.30 pm
Metro B Colosseo

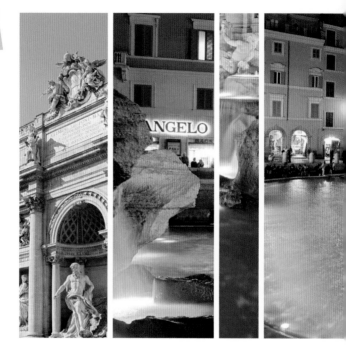

FONTANA DI TREVI

Piazza di Trevi // Centro Storico

Bus 71 Piazza San Silvestro

Day or night, the Trevi Fountain is a magnet for people. Visitors can't resist the temptation of throwing a coin over their shoulder into the fountain in order to be ensured a return to Rome. Under a triumphal arch in the center of the fountain, which emerges from the south wall of 18th century Palazzo Poli, god of the sea Neptune stands on a travertine shell chariot pulled by horses and escorted by water gods known as the Tritons.

Tags wie nachts ist die Fontana di Trevi ein großer Anziehungspunkt: Nicht-Römer können der Versuchung nicht widerstehen, ein Geldstück über die Schulter ins Wasser zu werfen, um sich eine Rückkehr nach Rom zu sichern. In der Mitte des Brunnens, der an die Südfassade des Palazzo Poli aus dem 18. Jahrhundert gebaut wurde, steht der Meeresgott Neptun unter einem dreiachsigen Triumphbogen. Sein von Pferden gezogener Muschelwagen aus Travertin wird von Wassergöttern, den Tritonen, begleitet.

De jour comme de nuit, la Fontaine de Trevi attire les passants. Les touristes ne peuvent s'empêcher d'y jeter une pièce de monnaie par dessus leur épaule pour s'assurer de revenir à Rome. Adossée à la façade sud du Palazzo Poli du 18e siècle, la niche principale abrite en son centre Neptune, le Dieu des mers, elle est surmontée d'un arc de triomphe à trois arches. Son char de travertin en forme de coquillage, tiré par des chevaux, est entouré de dieux marins, les Tritons.

La Fontana di Trevi è un' attrazione sia di giorno sia di notte: nessun visitatore resiste alla tentazione di gettarvi di spalle una moneta perché si realizzi il desiderio di ritornare a Roma. La fontana, costruita adiacente al lato sud del XVIII secolo Palazzo Poli, è dominata al centro da Nettuno, dio del mare, incorniciato da un arco trionfale a tre fornici. Il suo cocchio di travertino a forma di conchiglia è trainato da cavalli accompagnati da tritoni, ossia dei del mare.

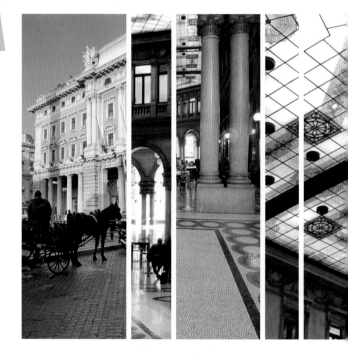

GALLERIA ALBERTO SORDI

Centro Storico
Tel.: +39 06 69 19 07 69
www.galleriaalbertosordi.it

Mon–Thu 8.30 am to 9 pm,
Fri–Sat 8.30 am to 10 pm,
Sun 9.30 am to 9 pm
Metro A Barberini, Bus 62 Largo Chigi, Bus 71 Piazza San Silvestro

While the former Galleria Colonna is too small to be in the same league as similar shopping malls in Milan and Naples, it has become a first-rate destination in its own right since its restoration in 2003, when it was renamed in honor of the famous actor Alberto Sordi. A wide range of stores attract customers, and a café in the center of the Galleria is a popular hangout to take a break from shopping. Occasionally, the Galleria also organizes exhibitions and concerts.

Mit den ähnlich gestalteten Galerien in Mailand und Neapel kann die Galleria Alberto Sordi schon aufgrund ihrer Größe nicht mithalten – trotzdem ist die frühere Galleria Colonna seit ihrer Restaurierung und Umbenennung zu Ehren des beliebten Schauspielers im Jahr 2003 zu einem großen Anziehungspunkt geworden. Geschäfte warten auf Kundschaft, ein Café im Mittelgang erfreut sich reger Beliebtheit. Hin und wieder finden in der Galerie zudem Ausstellungen oder Aufführungen statt.

De par sa petite taille, la Galleria Alberto Sordi ne fait pas le poids face aux deux galeries similaires de Milan et Naples. Et pourtant, l'ancienne Galleria Colonna, qui fut restaurée et rebaptisée en 2003 en hommage à l'acteur Alberto Sordi, attire bon nombre de visiteurs. Elle abrite diverses boutiques et un café à la popularité sans limite. Des expositions et représentations y ont régulièrement lieu.

Già per dimensioni, la Galleria Alberto Sordi non può reggere il confronto con strutture di questo tipo situate a Milano e a Napoli, ma da quando nel 2003 è stata ristrutturata e ribattezzata in onore dell'amato attore italiano, la già Galleria Colonna è diventata un forte polo d'attrazione. Ad attendere i clienti ci sono vari negozi e lungo il corridoio si trova un caffè dall'atmosfera effervescente. Di tanto in tanto, la galleria ospita anche mostre o rappresentazioni.

Now that the Monument to Vittorio Emanuele II is open to visitors, it is a popular attraction because of the fantastic view from the top platform. While in the past it was typically taken in as whole, now it is possible to study architectural details up close: the bronze equestrian statue of King Victor Emmanuel, the base of which is adorned with the symbols of major Italian cities, the Tomb of the Unknown Soldier from World War I, or the two horse-drawn chariots on the roof.

Seit das Nationaldenkmal für König Viktor Emanuel II. wieder begehbar ist, erfreut es sich bei Besuchern wegen der Aussicht von der obersten Plattform reger Beliebtheit. Und während es früher eher als Ganzes wahrgenommen wurde, kommen aus der Nähe nun auch Details zur Geltung: darunter die bronzene Reiterstatue des Königs, an deren Fuß wichtige italienische Städte symbolisiert sind, das Grab des Unbekannten Soldaten aus dem Ersten Weltkrieg oder die beiden Quadrigen auf dem Dach.

La vue du haut de la plateforme supérieure du monument dédié au roi Victor-Emmanuel II, rouvert depuis peu, jouit d'une grande popularité auprès des visiteurs. On peut admirer l'édifice dans son ensemble puis s'intéresser aux détails comme la statue équestre en bronze du roi, au pied de laquelle sont symbolisées des villes italiennes, la tombe du Soldat Inconnu de la Première Guerre Mondiale et les deux quadriges sur le toit.

Da quando è di nuovo aperto al pubblico, questo monumento nazionale dedicato a Re Vittorio Emanuele II raccoglie ampi consensi per il panorama offerto dalla piattaforma superiore. Se prima, inoltre, lo si apprezzava soprattutto nel suo complesso, ora ne vengono valorizzati anche i dettagli, come la statua equestre in bronzo del Re, ai cui piedi sono simboleggiate importanti città italiane, la tomba del Milite Ignoto, della prima guerra mondiale, o le due quadrighe sul tetto.

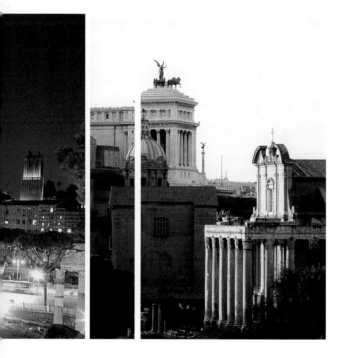

MONUMENTO NAZIONALE
A VITTORIO EMANUELE II

Piazza Venezia // Centro Storico
Tel.: +39 06 69 91 71 8

Daily 9.30 am to 4.30 pm
Panoramic terrace:
Mon–Thu 9.30 am to 6 pm,
Fri–Sun 9.30 am to 7.30 pm
Bus 40 Piazza Venezia, Bus 64 or Bus 70 Piazza Venezia

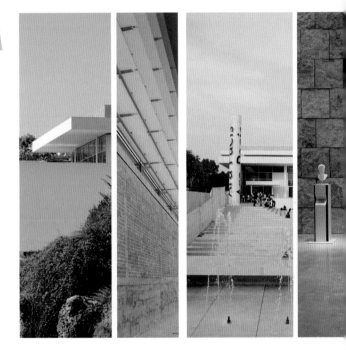

MUSEO DELL'ARA PACIS

Lungotevere in Augusta/angolo
Via Tomacelli // Centro Storico
Tel.: +39 06 06 08
www.arapacis.it

Tue–Sun 9 am to 7 pm
Bus 628 LGT Augusta/Ara Pacis

An almost square structure of Carrara marble, richly decorated with reliefs, encloses the actual Ara Pacis, or Altar to Peace, erected to celebrate the long period of peace established by Emperor Augustus. Since 2006, the altar has been integrated into a museum designed by architect Richard Meier to protect it from smog and the elements. After hours, the Ara Pacis can be admired through the glass walls.

Ein fast quadratischer Bau aus Carrara-Marmor, reich verziert mit Reliefs, umschließt den eigentlichen Opferaltar Ara Pacis, der errichtet wurde, um den von Kaiser Augustus gebrachten langen Frieden zu zelebrieren. Seit 2006 ist der Altar zum Schutz vor Smog und Witterung in ein Museum integriert, das der Architekt Richard Meier entworfen hat. Dank der Glasfassade kann man die Ara Pacis auch nach den Öffnungszeiten bewundern.

L'autel Ara Pacis, situé dans une enceinte presque carrée constituée de marbre de Carrare et somptueusement décorée avec des reliefs, fut construit sous Auguste pour célébrer les longues années de paix apportées par l'Empereur. En 2006, pour le protéger des intempéries, l'autel fut intégré à un musée conçu par l'architecte Richard Meier. La façade de verre permet d'admirer l'autel également en dehors des heures d'ouverture.

L'Ara Pacis, un altare costruito per celebrare il lungo periodo di pace che accompagnò il regno dell'imperatore Augusto, è costituita da un recinto quasi quadrato di marmo di Carrara con raffinate decorazioni a rilievo. Per proteggerla da smog e intemperie, nel 2006 è stata integrata in un museo progettato dall'architetto Richard Meier, e ora si trova dietro una facciata di vetro che consente di ammirarla anche al di fuori degli orari di apertura alle visite.

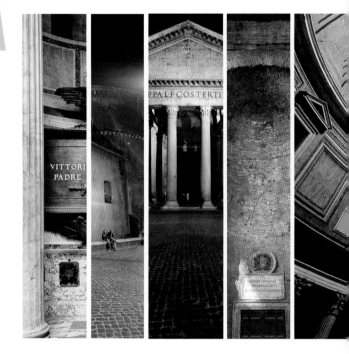

PANTHEON

Piazza della Rotonda // Centro Storico
Tel.: +39 06 68 30 02 30

Mon–Sat 8.30 am to 7.30 pm,
Sun 9 am to 6 pm
Bus 64 or Bus 492 Argentina

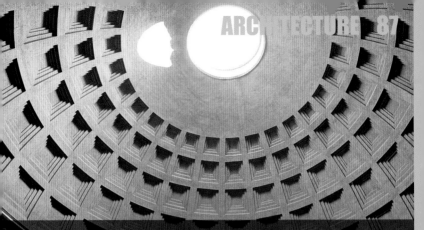

The Pantheon, dedicated in 27 BC and rebuilt 150 years later after a huge fire, is considered to be the best preserved building from antiquity. Large bronze doors open to the round interior of the church where painter Raphael, King Victor Emanuel II and other dignitaries are buried. The circular opening, 30 ft. wide, in the center of the coffered dome, which was once gilded, allows light and rain into the interior.

Das Pantheon, das 27 v. Chr. geweiht und wegen Brandschädigung rund 150 Jahre später neu gebaut wurde, gilt als das am besten erhaltene Gebäude der Antike. Durch mächtige Bronzetüren gelangt man ins kreisrunde Innere der heutigen Kirche, in der unter anderen der Künstler Raffael und König Viktor Emanuel II. ihre letzte Ruhestätte fanden. Durch die 9 m weite Kreisöffnung im Zentrum der früher vergoldeten Kassettendecke gelangen sowohl Licht als auch Regen ins Innere.

Le Panthéon de l'an 27 av. J.C., qui subit plusieurs incendies, fut reconstruit 150 ans plus tard. Il est considéré comme l'édifice le mieux conservé de la Rome antique. Par de lourdes portes en bronze, on pénètre dans l'enceinte circulaire de l'église actuelle où Raphaël et le roi Victor-Emmanuel II entre autres reposent en paix. La coupole constituée autrefois de caissons d'or dévoile une grande ouverture de 9 m qui laisse passer la lumière mais aussi la pluie

Costruito nel 27 a.C. come tempio dedicato alle divinità e ricostruito 150 più tardi dopo che vari incendi lo avevano danneggiato, il Pantheon è considerato l'edificio dell'antichità meglio conservato. Imponenti porte di bronzo conducono nell'interno a pianta circolare dell'odierna chiesa, in cui riposano Raffaello e re Vittorio Emanuele II. L'apertura circolare ampia 9 m sul soffitto a cassettoni, che in origine era dorato, fa entrare sia la luce sia la pioggia.

The name of the Spanish Steps and the Piazza di Spagna is derived from Palazzo di Spagna at the southwestern end of the square, built as the Spanish embassy in the 17th century. However, it isn't individual buildings that attract people to the Piazza di Spagna, it's the atmosphere. Visitors enjoy sitting on the steps of the famous stairway below the church of Trinità dei Monti, watching the streams of people in this exclusive shopping district or listening to street musicians.

Der Name der Treppe und des Platzes leitet sich vom Palazzo di Spagna her, der am südwestlichen Ende des Platzes liegt und im 17. Jahrhundert als Spanische Botschaft errichtet wurde. Einzelne Gebäude zählen hier jedoch weit weniger als die Atmosphäre. Zahlreiche Besucher lassen sich auf den Stufen der eleganten Treppe unterhalb der Kirche Trinità dei Monti nieder, beobachten das Treiben in der beliebten und exklusiven Einkaufsgegend oder lauschen dem einen oder anderen Musiker.

Le nom des marches et de la place tire son origine du Palais di Spagna, construit au XVIIe siècle à l'extrémité sud-ouest de la place afin d'abriter l'ambassade d'Espagne. Les visiteurs sont bien plus attirés par l'atmosphère qui y règne que les bâtiments présents. Ils se prélassent sur les marches élégantes au pied de l'église Trinità dei Monti, observent le va-et-vient des passants faisant leurs emplettes ou les quelques musiciens qui s'y produisent.

Il nome della famosa piazza preceduta dalla scalinata deriva da Palazzo di Spagna, che sorge sul suo lato sud-ovest e fu costruito nel XVII secolo come sede dell'ambasciata spagnola. Ma ciò che conta qui non sono i singoli edifici, bensì l'atmosfera. I visitatori si abbandonano numerosi sui gradini dell'elegante scalinata ai piedi della Chiesa Trinità dei Monti, osservando il viavai in questa esclusiva e amata zona commerciale o ascoltando la musica di qualche artista di strada.

PIAZZA DI SPAGNA

Centro Storico

Metro A Spagna
Bus 119 Spagna

A

Piazza Navona, one of Rome's most beautiful squares, is built on the site of the Stadium of Domitian, and the houses still follow the shape of the antique sporting venue. In the middle of the square, which has retained its general appearance from the Middle Ages and Renaissance, is Gian Lorenzo Bernini's Fountain of the Four Rivers. The four gods at the corners personify the rivers Ganges, Nile, Danube and Río de la Plata, representing the continents known in Bernini's time.

Die Piazza Navona, einer der schönsten Plätze Roms, ist auf dem Gelände des einstigen Stadions von Kaiser Domitian angelegt, und in der Tat ist die Form der antiken Sportstätte noch in der Anlage der Häuser erkennbar. Im Zentrum des Platzes, der seine heutige Gestalt aus Mittelalter und Renaissance bewahrt hat, steht der Vier-Ströme-Brunnen von Gian Lorenzo Bernini. Er zeigt die personifizierten Flüsse Ganges, Nil, Donau und Río de la Plata – als Vertreter der zu Berninis Zeiten bekannten Erdteile.

La Piazza Navona, l'une des plus belles places de Rome, est construite sur les ruines de l'ancien stade de l'empereur Domitien dont elle conserve la forme exacte. Au centre d'une architecture de style moyenâgeux et Renaissance qui a été maintenue, se dresse la Fontaine des Quatre Fleuves de Gian Lorenzo Bernini. Les quatre fleuves, le Gange, le Nil, le Danube et le Rio de la Plata, qu'elle représente symbolisent les continents connus à l'époque de Bernini.

Piazza Navona, una delle più belle piazze della città, sorge sul sito dell'antico Stadio di Domiziano, e in effetti la disposizione delle case ne rivela ancora la forma di struttura sportiva. Al centro della piazza, che ha conservato la sua impronta medievale e rinascimentale fino ai giorni nostri, spicca la Fontana dei Quattro Fiumi del Bernini, dove le impersonificazioni dei fiumi Gange, Nilo, Danubio e Rio de la Plata simboleggiano i continenti conosciuti all'epoca dello scultore Bernini.

PIAZZA NAVONA

Centro Storico

Bus 64 Corso Vittorio Emanuele/Navona

GIAN LOR
BERNINI

No matter what newer architects have achieved, nobody has shaped the cityscape of Rome as much as Gian Lorenzo Bernini. Born in 1598 in Naples, he apprenticed as a sculptor to his father Pietro before he moved to Rome and entered the service of several popes, working in a Classical Baroque style. Urban VIII commissioned him to build the baldachin over the tomb of Saint Peter in Saint Peter's Basilica, to design the Triton Fountain, and to complete Palazzo Barberini, which belonged to Urban VIII's family. Under Innocent X, Bernini designed the Fountain of the Four Rivers on Piazza Navona and the colonnades on Saint Peter's Square. Bernini was able to dedicate time to other projects as well, including the design of the church of Sant'Andrea al Quirinale and the creation of significant sculptures, some of which can be seen in the Galleria Borghese, others in churches all over the Eternal City. Bernini died in Rome in 1680. He is buried in the Basilica di Santa Maria Maggiore.

Neue Architektur hin oder her – kein Architekt hat das Stadtbild Roms bisher so geprägt wie Gian Lorenzo Bernini. Der im Jahr 1598 geborene Neapolitaner lernte in der Bildhauerwerkstatt seines Vaters Pietro, bevor er nach Rom zog und sich mit seinem barocken Klassizismus in den Dienst wechselnder Päpste stellte. Urban VIII. betraute ihn mit dem Bau des Baldachins über dem Petrusgrab im Petersdom, der Gestaltung des Tritonenbrunnens und der Vollendung des familieneigenen Palazzo Barberini. Unter Innozenz X. errichtete Bernini den Vierströmebrunnen auf der Piazza Navona und die Kolonnaden auf dem Petersplatz. Im wahrsten Sinne des Wortes „nebenher" blieb Bernini immer noch genügend Zeit für Anderes: zum Beispiel den Bau der Kirche Sant'Andrea al Quirinale und das Anfertigen großartiger Skulpturen. Einige davon sind in der Galleria Borghese, andere in den Kirchen der Ewigen Stadt zu besichtigen. Bernini starb im Jahr 1680 in Rom. Begraben ist er in der Kirche Santa Maria Maggiore.

Des nouveaux bâtiments en tout lieu - jusqu'à présent, aucun architecte n'a autant influencé le paysage urbain de Rome que Gian Lorenzo Bernini. Ce Napolitain né en 1598 apprend dans l'atelier de sculpture de son père Pietro, avant de s'installer à Rome et de faire profiter différents papes romains de son architecture classique baroque. Il fut chargé par Urbain VIII de construire le baldaquin de la tombe de Saint-Pierre dans la Basilique Saint-Pierre, de concevoir la Fontaine des Tritons et d'achever son Palais Barberini. Sous Innocent X, il érigea la Fontaine des Quatre-Fleuves sur la Piazza Navona et les colonnades de la Place Saint-Pierre. Malgré un emploi du temps chargé, il s'occupe de la construction d'autres joyaux architecturaux comme l'église Sant'Andrea al Quirinale et se consacre à la sculpture. Certaines de ses statues sont exposées à la Galleria Borghese, d'autres dans des églises de Rome. Bernini mourut en 1680 à Rome, il repose dans l'église Santa Maria Maggiore.

Per quanto operosi siano gli architetti di oggi, finora nessuno è riuscito a plasmare il profilo della città come Gian Lorenzo Bernini. Nato nel 1598 a Napoli, Bernini studiò nel laboratorio di scultura del padre Pietro prima di trasferirsi nella capitale e lavorare al servizio di vari Papi portando alla massima espressione il suo classicismo barocco. Urbano VIII gli commissionò il baldacchino per la tomba di San Pietro, la Fontana di Trevi e il completamento di Palazzo Barberini, allora appartenente all'omonima famiglia. Sotto Innocenzo X Bernini eseguì la Fontana dei Quattro Fiumi di Piazza Navona e il colonnato di Piazza San Pietro. Accanto a queste incommensurabili opere, a Bernini restava ancora tempo per altro, come la costruzione della Chiesa di Sant'Andrea al Quirinale e la realizzazione di mirabili sculture. Alcune si possono ammirare presso la Galleria Borghese, altre in varie chiese della Città Eterna. Bernini morì a Roma nel 1680 e oggi riposa nella Chiesa di Santa Maria Maggiore.

PALAZZO DEI CONGRESSI

The EUR district (Esposizione Universale di Roma) was originally planned as the site of the 1942 World's Fair which, because of the war, never took place. Today EUR is a residential, business and arts district which has plans to become the "downtown" of Rome. Until now, its architecture was dominated by the Palazzo della Civiltà Italiana with its 216 arches and the Palazzo dei Congressi. This could soon change with buildings designed by noted architects such as Massimiliano Fuksas and Renzo Piano.

Das EUR-Viertel – EUR steht für Esposizione Universale di Roma – entstand zur Weltausstellung 1942, die wegen des Krieges jedoch nie stattfand. Heute ist es Wohn-, Geschäfts- und Kunstviertel zugleich, das zur „City" Roms aufsteigen möchte. Während es bisher von den 216 Bögen des Palazzo della Civiltà Italiana und dem Palazzo dei Congressi symbolisiert wurde, könnten bald die Bauten namhafter Architekten wie Massimiliano Fuksas und Renzo Piano dem Viertel ihren Stempel aufdrücken.

Le quartier EUR (Exposition Universale di Roma) fut créé pour l'exposition universelle de 1942, finalement annulée à cause de la guerre. De nos jours, ce quartier résidentiel, commercial et artistique aimerait s'élever au rang de quartier branché de Rome. Ce quartier, symbolisé par des édifices comme les 216 arcs du Palazzo della Civiltà Italiana et le Palazzo dei Congressi, comptera bientôt des chefs d'œuvre d'architectes renommés comme Massimiliano Fuksas et Renzo Piano.

Il quartiere EUR (Esposizione Universale di Roma) fu progettato per l'Esposizione Universale del 1942, che però non si tenne mai a causa della guerra. Oggi è un quartiere residenziale, commerciale e artistico che vuole spingere Roma verso lo status di "City". Finora era simboleggiato dai 216 archi del Palazzo della Civiltà Italiana e del Palazzo dei Congressi, ma i progetti di architetti quali Massimiliano Fuksas e Renzo Piano potrebbero presto dare una nuova impronta al quartiere.

EUR

EUR

Metro B EUR Fermi

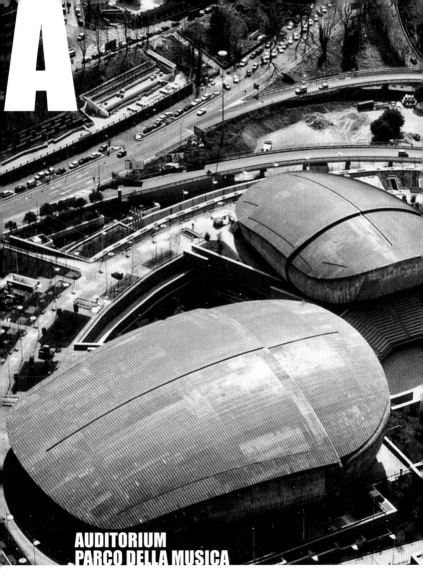

A

AUDITORIUM
PARCO DELLA MUSICA

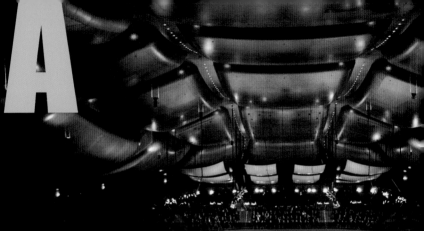

At the beginning of the new millennium, Rome finally got a contemporary music complex—and what a stunner it is! Designed by Renzo Piano, the Auditorium Parco della Musica consists of three large concert halls that meet even the most exacting technical requirements, be it for classical music or jazz, dance performances, readings, plays, or movies. The complex also includes a restaurant, conference and exhibition facilities, and an open air theater—perfect for warm summer days.

Anfang des neuen Jahrtausends bekam auch Rom einen zeitgemäßen Konzertsaal, und was für einen. Renzo Piano entwarf das Auditorium Parco della Musica, das aus drei Musiksälen besteht. Diese werden allen technischen Anforderungen gerecht – egal ob klassische Musik oder Jazz, Tanzveranstaltungen, Lesungen, Theater- oder Filmvorführungen geboten werden. Außerdem gibt es auf dem Areal ein Restaurant, Konferenz- und Ausstellungsräume und für die warmen Sommertage eine Freilichtbühne.

À l'aube du IIe millénaire, une salle de concert moderne digne de ce nom fut érigée à Rome. L'Auditorium de Renzo Piano se compose de trois salles de concert. Celles-ci sont équipées d'installations techniques adaptées à des concerts de musique classique et jazz, des spectacles de danse et de théâtre, des lectures et des projections de films. On y trouve aussi un restaurant, des salles de conférences et d'exposition ainsi qu'un théâtre en plein air pour les représentations estivales.

All'inizio del nuovo millennio anche a Roma è stata costruita una sala da concerto in stile moderno, un'opera davvero mirabile che porta la firma di Renzo Piano. L'Auditorium Parco della Musica si compone di tre sale provviste di ogni dotazione tecnica: per musica classica o jazz, spettacoli di danza, letture, rappresentazioni teatrali o proiezioni di film. Ci sono inoltre un ristorante, sale per conferenze ed esposizioni e un palcoscenico all'aperto per le calde giornate estive.

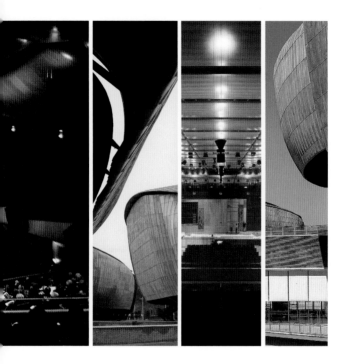

AUDITORIUM
PARCO DELLA MUSICA

Viale Pietro de Coubertin 30 // Flaminio
Tel.: +39 06 80 24 12 81
www.auditorium.com

Tram 2 Apollodoro

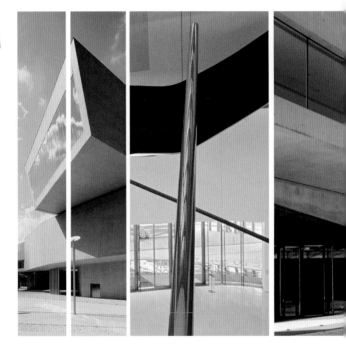

MAXXI – MUSEO NAZIONALE DELLE ARTI DEL XXI SECOLO

Via Guido Reni 6 // Flaminio
Tel.: +39 06 39 96 73 50
www.maxxi.beniculturali.it

Tue, Wed, Fri and Sun 11 am to 7 pm,
Thu and Sat 11 am to 10 pm
Tram 2 Apollodoro

Designed by star architect Zaha Hadid, the long-awaited National Museum of 21st Century Arts—"MAXXI" in short—opened in May of 2010 after a decade of construction. Built on the site of a former military installation, this structure of concrete and glass is as dynamic on the outside as it is on the inside, where suspended corridors and stairs connect the various exhibition areas. In addition to art, the museum also puts on exhibitions focusing on 20th century architecture.

Seit Mai 2010 verzückt das lang erwartete und von Stararchitektin Zaha Hadid konzipierte Nationalmuseum für die Kunst des 21. Jahrhunderts, kurz MAXXI genannt, seine Besucher. Auf einem alten Militärgelände erhebt sich der Bau aus Beton und Glas, der von außen genauso dynamisch wirkt wie von innen. Dort verbinden frei schwebende Korridore und Treppen die einzelnen Ausstellungsbereiche. Neben der Kunst werden immer auch Ausstellungen zur Architektur des 20. Jahrhunderts präsentiert.

Depuis mai 2010, les visiteurs s'extasient devant le musée national longtemps attendu, MAXXI, conçu par l'architecte de renom Zaha Hadid pour accueillir des œuvres d'art du XXIe siècle. Cet édifice de béton et de verre, dont l'architecture extérieure et intérieure subjugue par son dynamisme, fut érigé dans un ancien camp militaire. Les salles d'expositions sont reliées par des corridors et des escaliers en suspension. Des expositions d'art et d'architecture du XXe siècle y ont lieu.

Da maggio 2010 i visitatori possono finalmente ammirare il tanto atteso MAXXI (che sta per Museo Nazionale delle Arti del XXI secolo), progettato dall'architetto di grido Zaha Hadid. L'edificio, in vetro e cemento, sorge in una zona militare e presenta un assetto dinamico all'esterno quanto all'interno, dove le aree espositive sono collegate da scale e corridoi sospesi. Accanto alle opere d'arte il museo presenta anche mostre dedicate all'architettura del XX secolo.

MOSCHEA DI ROMA

Viale della Moschea 85 // Parioli
Tel.: +39 06 80 82 25 8
www.moscheadiroma.com

Wed, Sat 9 am to 11.30 am
Train Roma-Viterbo Monte Antenne
Bus 230 Moschea/Forte Antenne

Architects Paolo Portoghesi, Vittorio Gigliotti, and Sami Mousawi designed this mosque and the adjoining Islamic cultural center. Opened in 1995, the Moschea di Roma was the largest mosque in Europe for many years. Its highest and stylistically most striking element is the vaulted roof in the prayer hall, inspired by the domes of the great mosques of Córdoba and Tlemcen. The architects drew inspiration from many sources for the mosque's construction materials and the gardens.

Entworfen haben die Moschee und das dazugehörige islamische Kulturzentrum die Architekten Paolo Portoghesi, Vittorio Gigliotti und Sami Mousawi. Viele Jahre lang galt die 1995 eingeweihte Moschea di Roma als die größte in Europa. Ihr höchstes und stilistisch markantestes Element ist das Gewölbe im Gebetssaal, das von den Kuppeln der großen Moscheen in Cordoba und Tlemcen inspiriert ist. Auch bei den Gärten und den verwendeten Materialien des Baus wurde auf diverse Vorbilder zurückgegriffen.

La mosquée et le centre culturel musulman sont l'œuvre de Paolo Portoghesi, Vittorio Gigliotti et Sami Mousawi. La Mosquée de Rome, inaugurée en 1995, fut longtemps considérée comme la plus grande en Europe. L'élément le plus marquant constitue la voûte de la salle des prières, inspirée des coupoles des mosquées de Cordoba et Tlemcen. Pour l'aménagement des jardins et le choix des matériaux, les architectes se sont inspirés d'autres modèles d'architecture.

I progetti della moschea e dell'annesso centro di cultura islamico sono degli architetti Paolo Portoghesi, Vittorio Gigliotti e Sami Mousawi. Per molti anni la moschea di Roma, inaugurata nel 1995, è stata considerata la più grande d'Europa. L'elemento stilisticamente più alto e significativo è la cupola della sala di preghiera, ispirata alle grandi moschee di Cordova e Tlemcen. Altri modelli sono stati d'ispirazione anche per i giardini e per i materiali impiegati.

SANTA MARIA JOSEFA DEL CUORE DI GESÙ

Piazza Santa Maria Josefa del
Cuore di Gesù 25 // Ponte di Nona
Tel.: +39 06 22 48 44 32

Daily 5 pm to 8 pm
Bus 051 Riserva Nuova/Abbateggio or Mazzolari/Schweitzer

Designed by Garofalo Miura and dedicated in 2001, the church of Santa Maria Josefa del Cuore di Gesù is located in Castelverde di Lunghezza within the diocese of Rome. Particularly striking are the community center painted red, the tall bell tower, and the tall main structure with its square footprint. White concrete panels reflect the light from its façade all the way into the presbytery. The church's patron saint, who died in 1912, was canonized in October of 2000.

Bei der im Jahr 2001 geweihten und im zu Rom gehörenden Castelverde di Lunghezza gelegenen Kirche Santa Maria Josefa del Cuore di Gesù des Architekturbüros Garofalo Miura springen einem sofort der rote Anstrich des Gemeindezentrums, der hohe Glockenturm und der hohe quadratische Hauptbau ins Auge, von dessen Fassade das Licht durch weiße Zementpaneele bis zum Chorraum gelenkt wird. Die Patronin der Kirche, die 1912 verstarb, war im Oktober 2000 heiliggesprochen worden.

Située dans la zone romaine Castelverde di Lunghezza, l'église Santa Maria Josefa del Cuore di Gesù, sacrée en 2001 et conçue par le cabinet d'architectes Garofalo Miura, en étonne plus d'un par la couleur rouge de sa paroisse, son haut clocher et son bâtiment principal carré dont la façade, parsemée de panneaux de ciment blanc, dirige la lumière jusque dans le chœur. La patronne de l'église mourut en 1912 et fut canonisée en octobre 2000.

Consacrata nel 2001 e situata nella frazione di Castelverde di Lunghezza, la Chiesa di Santa Maria Josefa del Cuore di Gesù dello studio di architettura Garofalo Miura colpisce per il colore rosso del suo centro socioculturale, per l'alto campanile e l'imponente struttura a pianta quadrata, i cui pannelli di cemento bianco della facciata fanno convergere la luce fino al presbiterio. La beata cui è dedicata la chiesa morì nel 1912 e venne santificata nell'ottobre del 2000.

A

Castel Sant'Angelo was originally built as a mausoleum for Emperor Hadrian in the 2nd century but it has been used for many different purposes since then. A fortress for besieged popes in the Middle Ages, an aristocratic residence and then a prison, Castel Sant'Angelo is now a museum dedicated to its own history. The view of St. Peter's Basilica is phenomenal. The Ponte Sant'Angelo, leading to the castle, dates back to Hadrian's time; it was updated by Bernini.

Ursprünglich war die Engelsburg als Grab-stätte für Kaiser Hadrian im 2. Jahrhun-dert gedacht – doch seither wurde sie auf die unterschiedlichsten Arten genutzt. Im Mittelalter Schutzburg bedrohter Päpste, dann Adelssitz, dann Gefängnis, beherbergt die Engelsburg heute ein Museum über ihre Geschichte, von dem aus man einen sagenhaften Blick auf den Petersdom genießt. Die bereits unter Hadrian gebaute Engelsbrücke, die auf die Burg zuführt, geht in ihrer heutigen Gestalt auf Bernini zurück.

Ce Château conçu pour être le mausolée de l'empereur Hadrien au 2e siècle, a eu des fonctions diverses et variées. Après avoir servi de repère de protection aux papes menacés au Moyen-âge, il devint un site noble pour se transformer ensuite en prison. Aujourd'hui, il abrite un musée qui relate son histoire. Du haut du château, on a une vue imprenable sur la Basilique Saint-Pierre. Le pont menant au château furent conçus sous le règne d'Hadrien et modernisés par Bernini.

Edificato nel II secolo come mausoleo per l'Imperatore Adriano, nel corso dei secoli Castel Sant'Angelo ha assolto a svariate funzioni. Nel Medioevo offrì rifugio ai Papi sotto minaccia, poi fu dimora nobiliare e in seguito prigione, mentre oggi ospita un museo dedicato alla sua storia da cui si apre un'incantevole vista sulla Basilica di San Pietro. Il ponte Sant'Angelo, che conduce al castello, fu originariamente costruito sotto Adriano, ma la sua odierna struttura è opera del Bernini.

CASTEL SANT'ANGELO

Lungotevere Castello, 50 // Prati
Tel.: +39 06 68 19 11 1
www.castelsantangelo.com

Tue-Sun 9 am to 7 pm
closed on Dec 25th and Jan 1st

QUARTIERE COPPEDÈ

Via Tagliamento,
Via Arno, Piazza Mincio // Salario

Bus 92 Buenos Aires

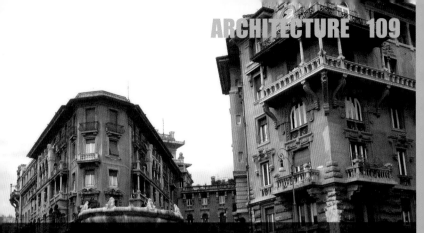

The Quartiere Coppedè, built in the 1920s, is best entered through the monumental arch between the embassy palaces, quintessential examples of the eclectic style of architect Gino Coppedè. He juxtaposed shapes and styles—Gothic, Baroque, Renaissance with symbols from many parts of the world, including Babylon, Vienna and his Tuscan home. Coppedè was famous for his sense of irony, apparent in the way he mixed these disparate elements.

Das Coppedè-Viertel aus den 1920er-Jahren betritt man am besten durch den monumentalen Torbogen zwischen den sogenannten Botschafterpalästen, denn sie repräsentieren die Quintessenz des eklektischen Stils des Architekten Gino Coppedè. Er mischt Formen und Stile – Gotik, Barock und Renaissance – mit Symbolen aus verschiedenen Teilen der Welt, darunter aus Babylon, Wien oder seiner toskanischen Heimat. Für die Ironie, mit der er diese Einflüsse mischte, war Coppedè berühmt.

Pour pénétrer dans le Quartier Coppedè datant des années 1920, il est suggéré de passer par les porches monumentaux situés entre les palais des ambassadeurs car ils symbolisent la quintessence du style éclectique de l'architecte Gino Coppedè. Il a associé des formes et styles différents, allant du gothique à la Renaissance en passant par le baroque, avec des symboles de régions comme Babylone, Vienne ou sa Toscane natale. L'ironie avec laquelle il a mélangé ces influences l'a rendu célèbre.

Al quartiere Coppedè, risalente agli anni 1920, si dovrebbe sempre accedere attraverso il grande arco che congiunge i cosiddetti Palazzi degli Ambasciatori, che sono la quintessenza dell'eclettticismo di questo architetto. Coppedè mescolava forme e stili – Gotico, Barocco e Rinascimento – con simboli ispirati a varie parti del mondo, come Babilonia, Vienna o la Toscana, sua terra natale, ed era famoso per l'ironia con cui fondeva queste influenze.

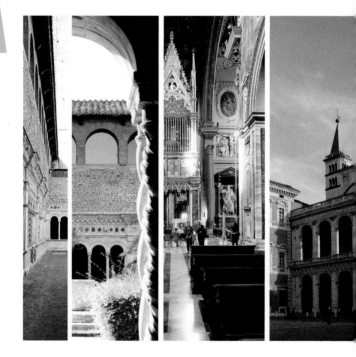

SAN GIOVANNI IN LATERANO

Piazza di San Giovanni in
Laterano 4 // San Giovanni
www.vatican.va/various/basiliche/san_giovanni/index_it.htm

Daily 7 am to 6.30 pm
Metro A San Giovanni

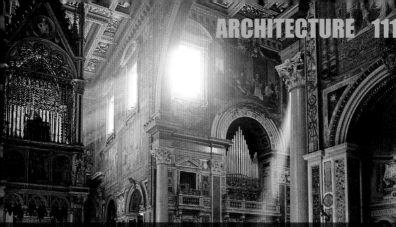

The Basilica of St. John Lateran is the official seat of the Pope. Founded in the 4th century AD, it is the oldest of the papal basilicas. Inset into its late-Baroque façade—adorned with 15 statues, each 23 ft. tall—are bronze doors from the curia in the Roman Forum, leading into the richly decorated interior designed by Borromini. Particularly remarkable is the magnificent wooden ceiling. The cloisters, a masterpiece of the Cosmatesque style from the 12th century, are also worth seeing.

San Giovanni in Laterano ist die Bischofskirche des Papstes – das erklärt ihren Rang seit ihrer Gründung im 4. Jahrhundert n. Chr. Nach einem Blick auf die spätbarocke Fassade mit 15 Statuen von 7 m Höhe betritt man durch Bronzetüren aus der Kurie des Forums das von Borromini gestaltete und reich verzierte Innere. Bemerkenswert ist unter anderem die prächtige Holzdecke. Auch der Kreuzgang lohnt einen Besuch, er ist ein Meisterwerk der Cosmatenkunst aus dem 12. Jahrhundert.

La basilique Saint-Jean-de-Latran est l'église épiscopale du pape ; ce qui explique le rang qu'elle occupe depuis sa construction au 4e siècle après J.C. Après avoir admiré la façade de style baroque et ses 15 statues de 7 m de haut, on passe par les portes en bronze provenant de la Curie du Forum pour découvrir un intérieur richement décoré par Borromini. Le plafond en bois somptueux est admirable. Le cloître, chef d'œuvre des Cosmati datant du 12e siècle, vaut le détour.

La Basilica di San Giovanni in Laterano è la sede ecclesiastica del Papa – il che spiega la sua appartenenza al più alto rango sin dalla sua fondazione, nel IV secolo d.C. Dopo uno sguardo alla facciata tardo-barocca abbellita da 15 statue alte 7 m, si entra attraverso porte bronzee provenienti dalla Curia Iulia nel sontuoso interno, opera del Borromini, in cui spicca il magnifico soffitto in legno. Merita una visita anche il chiostro, realizzato dai maestri cosmateschi nel XII secolo.

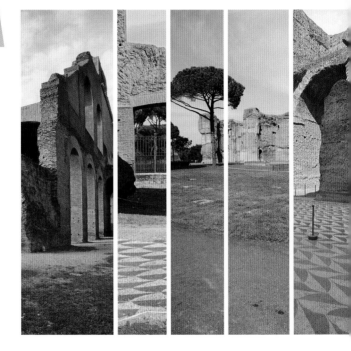

TERME DI CARACALLA

Via delle Terme di Caracalla 52 // Terme di Caracalla
Tel.: +39 06 39 96 77 00
archeoroma.beniculturali.it/siti-archeologici/terme-caracalla

Mon 9 am to 2 pm,
Tue–Sun 9 am to 4.30 pm
Metro B Circo Massimo

The Baths of Caracalla, a square complex 1082 ft. in length and width and large enough for 1,500 guests, were not just public bathing facilities but also an important center of social life. In addition to soaking in warm and cold water, many leisure activities awaited visitors starting in the year 216 AD: reading, listening to talks, playing sports, exercising, or going for walks. Today, opera performances and concerts are held in the summer in front of this spectacular backdrop.

Die Caracalla-Thermen, die auf einem quadratischen Areal von 330 m Länge und Breite für 1 500 Gäste Platz boten, waren nicht nur Badeanstalt, sondern sozusagen Brennpunkt des gesellschaftlichen Lebens. Denn neben Baden in warmen und kalten Becken konnten die Römer ab 216 n. Chr. hier ihre Freizeit mit Lesen in der Bibliothek, Vorträgen, Sport und Gymnastik oder Spaziergängen verbringen. Im Sommer finden vor der spektakulären Kulisse Opernaufführungen und Konzerte statt.

Les thermes de Caracalla, construits sur une plaine carrée de 330 m de longueur et qui accueillaient jusqu'à 1 500 visiteurs, n'étaient pas seulement des bains publics mais également le centre de la vie en société. À partir de 216 après J.C., les Romains y venaient pour se baigner, mais également pour lire à la bibliothèque, écouter des discours, faire du sport et de la gymnastique ou se promener. En été, ce décor spectaculaire accueille opéras et concerts.

Le Terme di Caracalla, che con una superficie di 330 m potevano ospitare 1 500 persone, fungevano non solo da complesso termale, ma anche da centro nevralgico della vita sociale. Oltre a immergersi in vasche d'acqua calda e fredda, infatti, dal 216 d.C. i Romani vi potevano trascorrere il tempo libero leggendo libri in biblioteca, assistendo a recitazioni, praticando sport e ginnastica o passeggiando. D'estate le terme fanno da scenografia per concerti ed esibizioni operistiche.

Rome's main train station Termini takes its name from the ancient Baths (or thermae) of Diocletian nearby. Construction on the current building started before World War II and was completed in 1950 with the involvement of several architects. The entrance hall is 420 ft. wide and 105 ft. deep; in front of it are remnants of the Servian Wall from the 4th century BC. In celebration of the Great Jubilee of 2000, Termini was renovated and a large shopping mall built on its lower level.

Der heutige Bau des Hauptbahnhofs Termini, der seinen Namen den nahe gelegenen Thermen des Diokletian verdankt, wurde bereits vor dem Zweiten Weltkrieg begonnen und schließlich im Jahr 1950 als Werk mehrerer Architekten fertiggestellt. Die Vorhalle ist 128 m breit und 32 m tief, davor stehen Reste der Servianischen Stadtmauer aus dem 4. Jahrhundert v. Chr. Zum Heiligen Jahr 2000 wurde der Bahnhof saniert und in seinem Untergeschoss ein großes Einkaufszentrum errichtet.

La construction de l'édifice actuel de la gare centrale Termini, qui doit son nom aux Thermes de Dioclétien à proximité, fut commencée avant la deuxième Guerre Mondiale et achevée en 1950 sous la tutelle de plusieurs architectes. Devant le hall d'entrée de 128 m de long et 32 m de profondeur, on peut admirer une section de la muraille Servienne du IVe siècle av. J.C. La gare fut rénovée en l'an 2000 et le sous-sol abrite depuis un grand centre commercial.

I lavori di costruzione per l'odierno edificio della stazione Termini, che deve il nome alle vicine Terme di Diocleziano, iniziarono ancor prima della Seconda Guerra Mondiale e terminarono nel 1950 dopo l'intervento di vari architetti. La galleria che dà accesso alla stazione è ampia 128 m e profonda 32 m e sorge davanti ai resti delle Mura Serviane, del IV secolo a.C. Nel 2000 la stazione è stata ristrutturata e oggi nel suo seminterrato ospita un grande centro commerciale.

ROMA TERMINI

Piazza dei Cinquecento // Termini
www.grandistazioni.it/

Metro A and B Termini

CHIESA DELLA VISITAZIONE

Via dei Crispolti 142/144 // Tiburtino
Tel.: +39 06 43 53 08 55

Mon–Sat 8 am to noon and 4.30 to 8 pm,
Sun 8 am to 1 pm and 4.30 to 8 pm
Metro B Pietralata

In 1965, in the middle of the Cold War, architect Saverio Busiri Vici was commissioned to build the church della Visitazione; for him, the church represented hope for the future. This vision motivated him to exchange the ribs and longerons of the model airplanes he had loved as a boy for slabs and columns. He thought cement would be the perfect material to use: flexible yet sturdy. Later, some details were added to the structure that were not the work of Saverio Busiri Vici.

Mitten im Kalten Krieg wurde 1965 der Architekt Saverio Busiri Vici mit dem Bau der Kirche della Visitazione beauftragt. Für ihn sollte sie die Hoffnung auf die Zukunft darstellen. Deshalb tauschte er Spanten und Längsträger der Modellflugzeuge, die ihn als Jugendlicher fasziniert hatten, gegen Platten und Pfeiler ein. Zement schien ihm dafür das passende Material zu sein: anpassungsfähig und trotzdem robust. Einige später hinzugefügte Details stammen nicht von Saverio Busiri Vici.

La construction de l'église della Visitazione débuta en 1965, au cours de la guerre froide et sous la tutelle de l'architecte Saverio Busiri Vici. Pour lui, elle devait représenter l'espoir du futur. C'est ainsi qu'il échangea couples et longerons de modèles d'avions, sa passion d'enfance, contre plaques et piliers. Il utilisa du ciment pour la construction, ce qui lui paraissait le plus adapté et robuste. Les détails ajoutés par la suite ne sont pas de lui.

Nel 1965, nel pieno della guerra fredda, l'architetto Saverio Busiri fu incaricato della costruzione della chiesa della Visitazione. Secondo lui doveva rappresentare la speranza nel futuro. Lasciò quindi le intelaiature e i longheroni degli aeroplani modello che lo avevano appassionato da giovane per dedicarsi a piastrelle e pilastri. Il cemento gli sembrò il materiale più adatto: flessibile, ma robusto. Alcuni dettagli aggiunti in seguito non sono opera di Saverio Busiri Vici.

A

The Diocese of Rome commissioned several modern churches to be built to mark the Great Jubilee in 2000. One of these churches, the Chiesa di Dio Padre Misericordioso, was designed by American architect Richard Meier. Completed in 2003, the church represents a stylized ship—a traditional symbol for the universal church of God—while the three concave sails represent the Holy Trinity. The exterior walls are made of self-cleaning concrete to protect them from air pollution.

Zum Jubiläumsjahr 2000 sollten im Auftrag der Diözese Rom einige moderne Kirchen entstehen. Eine davon, die Chiesa di Dio Padre Misericordioso, entwarf der amerikanische Architekt Richard Meier. Die erst 2003 vollendete Kirche stellt ein stilisiertes Schiff dar - ein Symbol für die Universalkirche Gottes. Die drei konkaven „Segel" stehen für die Dreifaltigkeit. Um die weißen Außenwände vor der Luftverschmutzung zu schützen, bestehen sie aus selbstreinigendem Beton.

L'Église du Jubilée, construite à l'occasion du IIe millénaire sur ordre de l'archidiocèse de Rome, fait partie d'un programme de construction d'églises modernes. Elle fut conçue par l'architecte américain Richard Meier. Achevée en 2003, l'église a la forme d'un bateau, un symbole pour l'église universelle de Dieu. Les trois « voiles » concaves représentent la Sainte Trinité. Pour éviter la noirceur due à la pollution, elles furent construites en béton.

In occasione dell'anno giubilare del 2000, la diocesi di Roma commissionò alcune chiese in stile moderno. Una di queste è la chiesa di Dio Padre Misericordioso, progettata dall'architetto americano Richard Meier. La chiesa, completata solo nel 2003, appresenta una nave stilizzata, simbolo della chiesa universale di Dio. Le tre "vele" concave simboleggiano la trinità. Le pareti esterne di colore bianco sono state realizzate in cemento autopulente per proteggerle dallo smog.

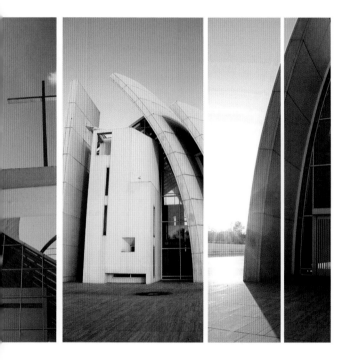

CHIESA DI DIO PADRE
MISERICORDIOSO

Largo Terzo Millennio 8-9 // Tor Tre Teste
Tel.: +39 06 23 15 83 3
www.diopadremisericordioso.it

Daily 7.30 am to 12.30 am and 3.30 pm to 7.30 pm
Bus 14 from Termini to Togliatti / Abelie, then Bus 565
to Tovaglieri / Ermoli

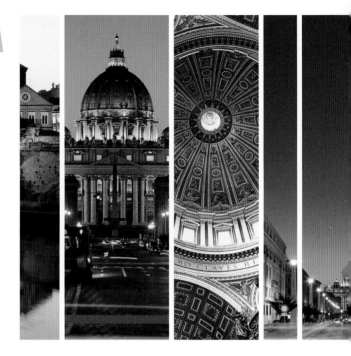

SAN PIETRO

Piazza San Pietro // Vaticano
Tel.: +39 06 69 88 37 31
www.vatican.va/various/basiliche/san_pietro/index_it.htm

Apr–Sep 7 am to 7 pm,
Oct–Mar 7 am to 6.30 pm
Bus 40 Traspontina/Conciliazione
Bus 64 Cavalleggeri/San Pietro, Tram 19 Risorgimento

St. Peter's Basilica is one of the largest churches in the world and an architectural masterpiece. The most famous architects of their time worked on the structure we see today. We have Michelangelo to thank for the incomparable dome, Carlo Maderna designed the façade, and Bernini is responsible for St. Peter's Square. The 55 ft. wide colonnades of St. Peter's Square allegorically encompass Rome and the world. Visitors will discover numerous art treasures inside the church.

Der Petersdom ist eine der größten Kirchen der Welt und dazu ein architektonisches Meisterwerk. Die renommiertesten Architekten ihrer Zeit haben an der Vollendung des heutigen Baus gearbeitet. Michelangelo ist die unvergleichliche Kuppel zu verdanken, Carlo Maderna gestaltete die Fassade, und Bernini ist für den Petersplatz verantwortlich. Dessen 17 m breite Kolonnaden umfassen gleichnishaft Rom und die Welt. Im Inneren der Kirche warten zahlreiche Kunstschätze auf die Besucher.

La basilique Saint-Pierre est la plus grande église du monde et un chef d'œuvre d'architecture. Les architectes les plus célèbres de l'époque ont participé à l'achèvement de l'édifice actuel. L'incomparable coupole est l'œuvre de Michel-Ange, la façade, celle de Carlo Maderna et Bernini s'est occupé de la place Saint-Pierre dont les colonnades de 17 m de large paraissent englober Rome et le monde. Mille trésors attendent les visiteurs à l'intérieur de l'église.

La basilica di San Pietro è una delle chiese più grandi del mondo, nonché un capolavoro dell'architettura. L'edificio che vediamo oggi è il frutto del lavoro degli architetti più famosi del tempo. A Michelangelo si deve una cupola senza paragoni, Carlo Maderna ha realizzato la facciata e Bernini Piazza San Pietro, il cui colonnato largo 17 m abbraccia idealmente Roma e il mondo. All'interno della chiesa sono numerose le opere d'arte che attendono i visitatori.

DESIGN

D

While Milan continues to be the undisputed design capital of Italy, things have changed quite noticeably in Rome over the last two decades: hotels, restaurants, bars, and stores have been built or renovated and equipped with sophisticated design. In many places, expanses of glass, steel, futuristic shapes, and eye-popping colors create a striking contrast to the remnants of antiquity still visible everywhere. Some of the most important haute couture brands, including Fendi, Laura Biagiotti, and Valentino are headquartered in Rome. Many other famous alta moda brands are represented as well, most of them in Via dei Condotti or one of the adjacent streets. In this area, a very special event takes place once a year: the fashion show on the Spanish Steps. Models descend the steps like angels and, against this breathtaking backdrop, unveil to a star-studded audience the latest creations of world-renowned designers.

Obwohl unbestritten Mailand die italienische Designmetropole ist, hat sich diesbezüglich auch in Rom in den letzten zwei Jahrzehnten eine Menge getan: Hotels, Restaurants, Bars und Geschäfte wurden neu gebaut oder umgestaltet und mit durchdachtem Design versehen. Viel Glas, Stahl, futuristische Figuren und knallige Farben bilden mancherorts einen frischen Kontrast zur überall sichtbaren Antike. Darüber hinaus haben einige der größten Modemarken der Haute Couture, darunter Fendi, Laura Biagiotti und Valentino in Rom ihren Hauptsitz. Aber auch zahlreiche andere wohlbekannte Namen der Alta Moda sind in Rom vertreten – meist in der Via dei Condotti oder den angrenzenden Straßen. Hier ist es auch, wo einmal im Jahr ein besonderes Event stattfindet: die Modenschau auf der spanischen Treppe. Wie Engel schreiten die Models die Stufen herab und zeigen einem glamourösen Publikum vor herrlicher Kulisse, was weltberühmte Designer in den Monaten davor erschaffen haben.

Bien que Milan reste incontestablement la capitale italienne du design, Rome a fait une avancée considérable dans ce domaine au cours des deux dernières décennies : hôtels, restaurants, bars et boutiques ont été construits et réaménagés dans un style recherché. Verre, acier, modèles futuristes et couleurs vives apportent à certains endroits un agréable contraste au décor antique prédominant. En outre, certains des grands noms de la haute couture tels que Fendi, Laura Biagiotti et Valentino se sont implantés à Rome. On y trouve également des célèbres marques de la Alta Moda, installées principalement dans la Via dei Condotti ou les rues avoisinantes, où se tient annuellement le défilé de mode des marches espagnoles. Tels des anges, les modèles descendent les marches et dévoilent à un public très glamour les dernières créations de couturiers de renommée mondiale.

Anche se resta pur sempre Milano l'indiscussa capitale italiana del design, negli ultimi vent'anni in quest'ambito si è fatto molto anche a Roma: hotel, ristoranti, bar e negozi sono stati ricostruiti o ristrutturati con un attento studio di design. Vetro, acciaio, forme futuristiche e colori sgargianti formano in certi punti di Roma un piacevole contrasto con le onnipresenti testimonianze dell'antichità. È qui, inoltre, che hanno la sede principale alcune delle più grandi marche dell'haute couture, come Fendi, Laura Biagiotti e Valentino, ma nella capitale sono rappresentati anche numerosi altri nomi dell'alta moda di fama internazionale – soprattutto in Via dei Condotti o lungo le vie attigue. A Roma si svolge un importante evento di ricorrenza annuale: la sfilata di Piazza di Spagna. Come fossero angeli, le modelle scendono le scale di questa famosa piazza esibendo a un fascinoso pubblico le ultime creazioni di stilisti di fama mondiale in una cornice mozzafiato.

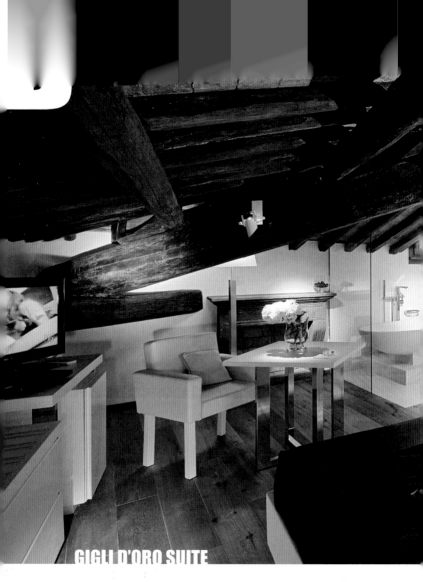

GIGLI D'ORO SUITE

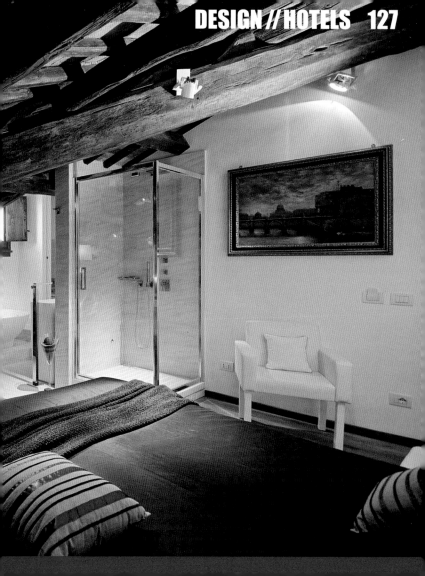

Not far from the Piazza Navona, this 15th century palace is still imbued with the flair of a former Roman residence and, with its old portals, stairways, and wooden floors, it provides the perfect framework for the Gigli d'oro Suite. The six luxurious suites are stylishly furnished with contemporary designer furniture and provide a high level of privacy: thanks to a separate entrance, guests can reach their suite directly from the street.

In der Nähe der Piazza Navona verfügt der Palazzo aus dem 15. Jahrhundert noch immer über das Flair einer ehemaligen römischen Residenz und bietet mit seinen alten Portalen, Treppenaufgängen und Holzböden den perfekten Rahmen für das Gigli d'oro Suite. Die sechs luxuriösen Suiten sind stilvoll mit zeitgenössischen Designermöbeln bestückt und garantieren den Gästen viel Privatsphäre: Sie sind dank eines separaten Eingangs direkt von der Straße aus zu erreichen.

Ce palais du XVe siècle situé près de la Piazza Navona possède encore le charme d'une ancienne résidence romaine. Ses portails, escaliers et planchers anciens constituent un décor idyllique pour le Gigli d'oro Suite. Les six suites de luxe sont décorées avec style de meubles de design contemporain et garantissent aux clients leur sphère privée car depuis la rue, elles sont accessibles par une entrée séparée.

Situato nei pressi di Piazza Navona, il palazzo del XV secolo conserva ancora l'atmosfera di un'antica residenza romana e offre con i suoi portali, le scalinate e i pavimenti in legno la cornice perfetta per i Gigli d'oro Suite. Le sei lussuose suite hanno un arredamento di classe con moderni mobili di design e garantiscono agli ospiti la massima riservatezza. Grazie al loro ingresso separato sono infatti accessibili direttamente dalla strada.

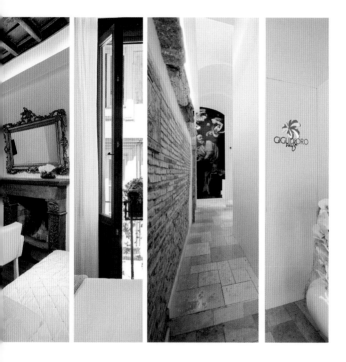

GIGLI D'ORO SUITE

Via dei Gigli d'Oro 12 // Centro Storico
Tel.: +39 06 68 39 20 55
www.giglidorosuite.com

Bus 70 Zanardelli

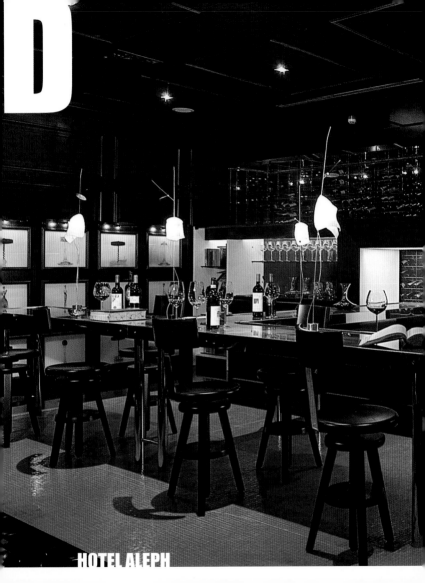

D

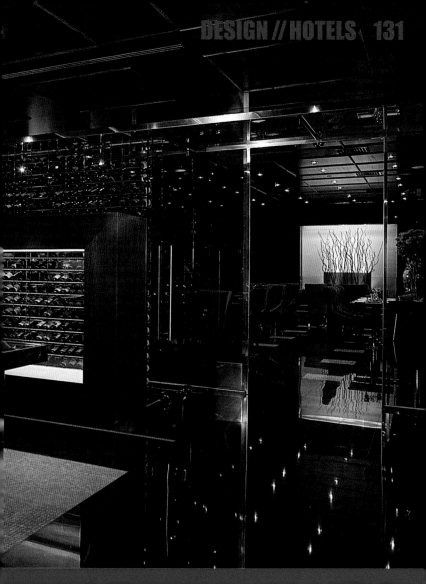

HOTEL ALEPH

Via di San Basilio 15 // Centro Storico
Tel.: +39 06 42 29 01
www.boscolohotels.com/fra/hotels/aleph/hotel_5etoiles_rome.htm

Metro A Barberini

Designed by architect Adam Tihany, Hotel Aleph is located just a stone's throw away from the famous Via Veneto and playfully interprets the designer's concept of heaven and hell. Defying expectations, heaven is found in the basement—in the spa, housed in the vaults of the old bank. Hell is located upstairs, where bright red dominates all the public areas, and even the meals served in Maremoto, the hotel restaurant, are red.

Nur einen Katzensprung von der berühmten Via Veneto entfernt liegt das von Adam Tihany entworfene Hotel Aleph, das vom Thema Himmel und Hölle inspiriert ist. Aber in umgekehrter Reihenfolge: In den unteren Etagen finden Gäste das Paradies vor, zum Beispiel im Spa. Oben erwartet sie die Hölle – kräftige Rottöne beleben hier alle öffentlichen Bereiche, und sogar die Gerichte im Hotelrestaurant Maremoto sind rot.

À deux pas de la célèbre Via Veneto, cet hôtel imaginé par l'architecte Adam Tihany est inspiré du thème du paradis et de l'enfer. Le paradis se trouve pourtant au sous-sol dans le centre spa où était située la salle du trésor de l'ancienne banque. À l'étage supérieur, les clients pénètrent dans l'enfer ; les pièces sont drapées de rouge et même les plats proposés dans le restaurant Maremoto arborent cette couleur.

A soli due passi dalla famosa Via Veneto sorge l'Hotel Aleph, progettato dall'architetto Adam Tihany e ispirato al tema paradiso e inferno. Il paradiso si trova però al piano interrato, ovvero nel caveau dell'ex edificio della banca dove è stata ricavata una zona wellness. L'inferno invece attende gli ospiti al piano superiore dove il rosso acceso domina tutti gli spazi comuni e persino i piatti del Maremoto, il ristorante dell'hotel.

To reach the lobby of Hotel Art, you pass through a white marble hallway illuminated by Enzo Catellani light fixtures. In the palace's past life, the lobby was actually a chapel, and this stylish hotel boasts a clever mix of secular and sacred elements while emphasizing light and color. Each of the hotel's four floors is color-coded; the corridor on each floor is either a bright yellow, orange, green, or blue, and the rooms match the color scheme of each floor.

Durch einen mit weißem Marmor gestalteten und mit Lichtquellen von Enzo Catellani beleuchteten Gang erreicht man die Empfangshalle des Hotel Art. Sie war zu früheren Zeiten des Palazzos eine Kapelle. Sakrales wird in dem stylischen Hotel also mit Profanem vermischt und dabei besonders viel Wert auf Licht und Farbe gelegt. So sind die Korridore auf den vier Stockwerken in knalligem Gelb, Orange, Grün und Blau gehalten, und auch die Zimmer sind diesem Farbschema angepasst.

On pénètre dans le hall d'entrée de l'hôtel Art par un couloir aux murs de marbre blanc, illuminé d'une installation d'Enzo Catellani. À l'époque du Palazzo, l'édifice abritait une chapelle. Le sacré et le profane se mélangent dans cet hôtel de style, où l'accent est particulièrement mis sur la lumière et les couleurs. Les corridors des quatre étages et les chambres présentent des tons vifs de

Attraversando un corridoio rivestito di marmo bianco e illuminato da creazioni di Enzo Catellani, si arriva nella hall del Hotel Art, l'antica cappella del palazzo. Il sacro si unisce al profano in questo hotel di stile dove illuminazione e colori rivestono particolare importanza. I corridoi dei quattro piani sono di tonalità accese gialle, arancio, verdi o blu. Anche nelle camere però non manca la stessa combi-

HOTEL ART

Via Margutta 56 // Centro Storico
Tel.: +39 06 32 87 11
www.hotelart.it

Metro A Spagna
Bus 119 Babuino/Fontanella

Portrait Suites, located above the Salvatore Ferragamo Men's Store in the Via dei Condotti, has a luxury townhouse feel. Its location comes as no surprise—after all, this fashion brand has operated hotels for over 15 years. The 14 rooms and studios are as stylish as you might expect and either face the lively Via Bocca di Leone or lead into an inner courtyard. Guests can enjoy breakfast in their rooms or on the lovely roof terrace with a view of the church Santa Trinità dei Monti.

Direkt über dem Salvatore Ferragamo Men's Store in der Via dei Condotti liegt das als Townhouse konzipierte Portrait Suites – kein Wunder, schließlich betreibt die Modemarke bereits seit über 15 Jahren auch Hotels. Entsprechend stilvoll sind die 14 Zimmer und Studios eingerichtet, die entweder auf die belebte Via Bocca di Leone oder in einen Innenhof führen. Frühstück wird im Zimmer oder – sehr lohnend – auf der Dachterrasse mit Blick auf die Kirche Santa Trinità die Monti serviert.

Cette maison urbaine est située juste au-dessus de la boutique de mode masculine Salvatore Ferragamo dans la Via dei Condotti – pas étonnant, quand on sait que la marque dirige également des hôtels depuis plus de 15 ans. Les 14 chambres et studios, aménagés avec goût, donnent sur l'avenue animée de la Via Bocca di Leone ou sur une cour intérieure. Le petit déjeuner peut être servi au lit ou sur le toit-terrasse d'où l'on peut contempler l'église Santa Trinità die Monti

Concepito come una townhouse, il Potrait Suites è proprio sopra il Men's store di Salvatore Ferragamo in Via dei Condotti. Ciò non deve sorprendere perché è da oltre 15 anni che la casa di moda gestisce anche hotel. 14 camere e studio arredati con altrettanto stile danno sulla vivace Via di Bocca Leone o sulla corte interna. La colazione è servita in camera o - e ne vale veramente la pena - sulla terrazza sul tetto con vista sulla chiesa di Santa Trinità dei Monti

PORTRAIT SUITES

Via Bocca di Leone 23 // Centro Storico
Tel.: +39 06 69 38 07 42
www.portraitsuites.com

Metro A Spagna

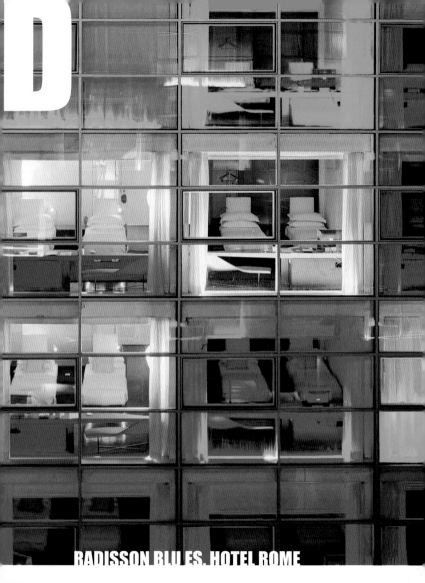

RADISSON BLU ES. HOTEL ROME

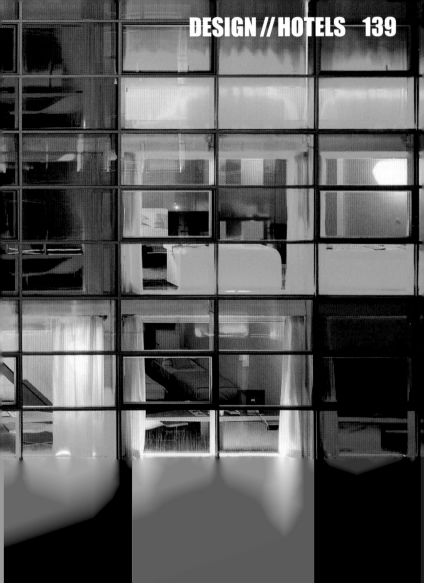

D

The construction of the Radisson posed a number of challenges to architects Jeremy King and Riccardo Roselli when ancient Roman relics were found on the site shortly before work was to begin. The architects quickly incorporated these relics into their minimalistic design, which was carried into the 232 rooms as well. To make the rooms as spacious as possible, they created an open bedroom/bathroom design. Colored lights under the windows illuminate the hotel's façade at night.

Der Bau des Radisson stellte die Architekten Jeremy King und Riccardo Roselli vor besondere Herausforderungen, als auf dem Areal kurz vor Baubeginn Reste aus der römischen Antike gefunden wurden. Diese integrierten die beiden kurzerhand in ihr minimalistisches Design, das sich auch in den 232 Zimmern fortsetzt. Um möglichst viel Raum zu schaffen, hoben sie die Trennung zwischen Bad und Schlafzimmer auf. Farbige Lichter unter den Fenstern bringen die Fassade des Hotels abends zum Leuchten.

Lors de la construction du Radisson, les architectes Jeremy King et Riccardo Roselli se trouvèrent confrontés à la découverte de restes de la Rome Antique et les intégrèrent à leurs plans. Les 232 chambres affichent un design minimaliste. Pour garantir un maximum d'espace, ils renoncèrent à séparer la chambre de la salle de bain. En soirée, la façade est illuminée de lampes colorées situées en-dessous des fenêtres.

La costruzione del Radisson ha posto Jeremy King e Riccardo Roselli davanti a grandi sfide. Poco prima dell'inizio dei lavori infatti sono stati rinvenuti nell'area antichi reperti romani che gli architetti hanno però velocemente integrato nel loro design minimalista, ripreso anche nelle 232 camere. Per avere quanto più spazio possibile, è stata annullata la divisione tra bagno e camera da letto. La sera luci colorate sotto le finestre fanno brillare la facciata dell'hotel.

RADISSON BLU ES.
HOTEL, ROME

Via Filippo Turati 171 // Esquilino
Tel.: +39 06 44 48 41
www.radissonblu.com/eshotel-rome

Metro A and B Termini
Bus 71 Turati / Mamiani

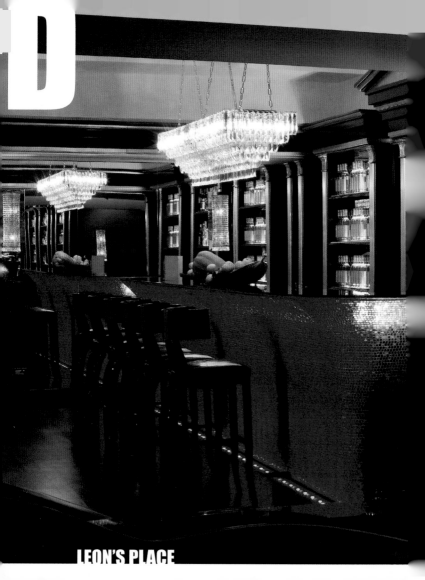

D

LEON'S PLACE

Via XX Settembre 90/94 // Porta Pia
Tel.: +39 06 89 08 71
www.leonsplace.it

Metro A and B Termini
Bus 61 and 62 Palestro

The lobby of Leon's Place, located in a 19th century palace, is almost reminiscent of a theater hall, while the 56 rooms and suites of this designer hotel are elegant yet restrained, kept in white, gray, and black. The Visionnaire Café cocktail bar forms a stark contrast to the rest of the hotel, illuminated in bright colors in the evenings. Yet the juxtaposition works—after all, different styles have been combined in Rome for thousands of years.

Die Lobby des Leon's Place in einem Palazzo aus dem 19. Jahrhundert erinnert fast schon an die Halle eines Theaters, während die 56 Zimmer und Suiten des Designhotels zurückhaltend-elegant in Weiß, Grau und Schwarz gehalten sind. Geradezu knallig wirkt dagegen die Cocktailbar Visionnaire Café, die abends in unterschiedlichen Farben angestrahlt wird. Der Mix macht's – schließlich wurden in Rom schon seit Jahrtausenden immer verschiedene Stile miteinander verbunden.

Le hall du Leon's Place, situé dans un palais du XIXe siècle, rappelle un hall de théâtre. Les 56 chambres et suites de cet hôtel design présentent des couleurs plus sobres mais élégantes comme le blanc, le gris et le noir. En revanche, le bar à cocktail Visionnaire Café, aux tons plus vifs, est illuminé en soirée d'un arc-en-ciel de couleurs. Le mélange fait son effet. Après tout, Rome combine les styles différents depuis des millénaires.

La lobby del Leon's Place, ospitato in un palazzo del XIX secolo, ricorda quasi il foyer di un teatro. Il bianco, il grigio e il nero invece sottolineano la sobria eleganza delle 56 camere e suite di questo hotel di design. Il cocktail bar Visionnaire Café colpisce piuttosto per i colori sgargianti che di sera lo illuminano. Il mix funziona: dopo tutto sono millenni che a Roma stili sempre diversi si mescolano.

Looking at it from the outside, you would never guess that Ripa's simple façade conceals a designer hotel, and the interior would amaze you even more. Underscored by bizarre shapes and bright colors, a futuristic design by the architect team of King/Roselli dominates the public spaces in this hotel. In the 170 rooms, furnishings are limited to the essentials. Even if you are not overnighting here, the elegant restaurant RipArteCafé is well worth a visit.

Von außen betrachtet würde hinter der schmucklosen Fassade beim Ripa niemand auf ein Designhotel schließen. Umso größer ist das Staunen im Inneren. Ein vom Architektenteam King/Roselli gestaltetes futuristisch anmutendes Design, unterstrichen von bizarren Formen und poppigen Farben, dominiert die öffentlichen Räume. In den 170 Zimmern beschränkt sich die Möblierung auf das Wesentliche. Auch wenn man nicht hier übernachtet, lohnt sich ein Besuch im schicken Restaurant RipArteCafé.

En contemplant la façade nue du Ripa, personne ne se doute qu'un hôtel design se cache derrière. L'effet est d'autant plus étonnant quand on pénètre à l'intérieur. Les salles communes présentent un design à l'aspect futuriste composé de formes bizarres et couleurs vives conçu par l'équipe d'architectes King/Roselli. L'aménagement des 170 chambres est spartiate. Même si on ne séjourne pas dans l'hôtel, un repas dans le restaurant RipArteCafé en vaut la peine.

Guardando la sobria facciata dall'esterno, nessuno penserebbe che il Ripa è un hotel di design. Ma lo stupore è ancora maggiore all'interno. Il design dall'aspetto futuristico del team di architetti King/Roselli, sottolineato da forme bizzarre e colori vistosi, domina negli ambienti comuni. Nelle 170 camere l'arredamento si limita all'essenziale. Anche se non si pernotta qui, vale la pena di visitare l'elegante ristorante RipArteCafé.

RIPA HOTEL

Via degli Orti di Trastevere 3 // Trastevere
Tel.: +39 06 58 61 1
www.ripahotel.com

Tram 8 Ippolito Nievo

Located in an alley near Piazza Navona, La Maison is one of the trendiest clubs in the city. Only a select few are admitted, but if you make it past the bouncers, you can celebrate the second half of the week cheek by jowl with stars and starlets or enjoy the softer sounds of the piano bar. In the summer, La Maison moves to the banks of the Tiber below the Castel Sant'Angelo and transforms itself into an entertainment complex complete with dance club, restaurant, bar, and pool.

In einer kleinen Gasse unweit der Piazza Navona liegt das La Maison, das sicher zu den schicksten Clubs der Stadt gehört. Zutritt wird nur einem ausgesuchten Publikum gewährt, doch wer an der Türstehern vorbeikommt, hat es geschafft und kann in der zweiten Wochenhälfte mit Stars und Sternchen feiern oder die sanften Klänge an der Piano Bar genießen. Im Sommer zieht das La Maison an Tiberufer unterhalb der Engelsburg und bietet dort Diskothek, Restaurants, Bar und Pools.

Située dans une impasse non loin de la Piazza Navona, La Maison compte parmi les clubs les plus chics de la ville. La clientèle se compose d'un public trié sur le volet par les portiers. Quand on a réussi à y mettre un pied, on y côtoie pendant la deuxième moitié de la semaine des vedettes renommées et moins connues et on se languit au piano bar sur de la musique douce. En été, La Maison s'installe au bord du Tibre avec sa discothèque, ses restaurants, bars et tables de billard.

In una viuzza poco distante da Piazza Navona si trova La Maison, sicuramente uno dei club più eleganti della città. L'ingresso è consentito solo a persone selezionate, ma quanti passano la prova dei buttafuori, verso la fine della settimana possono far festa con star e starlette o godersi le pacate note del piano bar. D'estate La Maison attira clienti sulle rive del Tevere all'ombra di Castel Sant'Angelo dove il club offre un servizio di discoteca, ristoranti, bar e piscine.

LA MAISON

Vicolo dei Granari 3 // Centro Storico
Tel.: +39 06 68 33 31 2
www.lamaisonroma.it

Wed–Sat midnight to 4 am
Bus 64 Corso Vittorio Emanuele / Navona
Bus 70 Senato

LUIGI & TONI

Luigi and Toni are movers and shakers in the nightlife of Rome. In 1995, they opened a steakhouse with disco and bar, and three years later a club called Le Bain because of its gigantic bathroom furnished with armchairs for casual conversations. At the time, the New York Times called it the most glamorous club in the world, where stars such as Leonardo di Caprio, Brad Pitt, and Claudia Schiffer were spotted frequently. The same is true today for La Maison with its impressive mix of baroque and modern furnishings and its innovative lighting. More recently, Luigi and Toni have focused on restaurants, for example Angelina. As was the case in their steakhouse and clubs, the two former athletes pay great attention to interior design. This is Luigi's area of expertise. When he sees a space, he knows instinctively what would look best—from the style of seating, to the colors of the walls, all the way to the décor. Since he loves France, many of his designs include subtle homages to Italy's neighbor.

Luigi und Toni sind Größen des römischen Nachtlebens. Bereits 1995 starteten die beiden Römer ein Steakhaus inklusive Disco und Bar, drei Jahre später einen Club – wegen seines riesigen Badezimmers, mit Sesseln zum Plaudern darin, Le Bain genannt. Die New York Times wählte es seinerzeit zum glamourösesten Club der Welt, in dem auch Stars wie Leonardo di Caprio, Brad Pitt und Claudia Schiffer gesehen wurden. Genau so wie heutzutage im La Maison, das durch seinen Mix aus barocker und moderner Einrichtung und seine Beleuchtung besticht. Doch abgesehen davon verlegen sich Luigi und Toni inzwischen mehr auf Restauration, zum Beispiel mit dem Angelina. Auch hier kommt es den beiden früheren Sportlern genau wie bei ihrem Steakhaus oder diversen Clubs auf eine adäquate Einrichtung an. Dafür ist Luigi zuständig. Er sieht Räume und hat bereits im Kopf, wie sie eingerichtet werden müssen – vom Stuhl über die Farbe der Wände bis zur Dekoration. Und da er ein großer Frankreich-Fan ist, erkennt man hie und da eine kleine Hommage an das Nachbarland.

Luigi et Toni sont des piliers de la vie nocturne romaine. En 1995, ces deux Romains ont ouvert un steakhouse avec discothèque et bar, trois ans plus tard ils inaugurent leur club, appelé Le Bain du fait de sa grande salle de bain aménagée de divans moelleux. Le New York Times le considéra comme le club le plus glamour du monde ; des vedettes comme Leonardo di Caprio, Brad Pitt et Claudia Schiffer y ont été vues. C'est également le cas à La Maison où les visiteurs seront séduits par l'intérieur baroque et moderne mais aussi l'éclairage. Entre-temps, Luigi et Toni se consacrent de plus en plus à la restauration, avec l'Angelina. Comme pour leurs autres établissements, ces anciens sportifs accordent une grande importance à la décoration intérieure. Et c'est Luigi le designer. En observant une pièce, il imagine déjà son aménagement, des chaises aux couleurs des murs, en passant par la décoration. Et comme c'est un grand admirateur de la France, il lui rend hommage au pays voisin.

Luigi e Toni sono due pilastri della vita notturna di Roma. I due romani aprirono già nel 1995 un ristorante specializzato in piatti di carne con discoteca e bar annessi, tre anni più tardi un locale notturno, detto Le Bain per il suo gigantesco bagno con tanto di poltrone per chiacchierare. Il New York Times lo nominò a suo tempo il club più glamour del mondo, dove sono state viste star come Leonardo di Caprio, Brad Pitt e Claudia Schiffer. Oggi questo vanto spetta al La Maison, che seduce con il suo mix di arredi barocchi e moderni e la straordinaria illuminazione. Tuttavia, oggi Luigi e Toni si dedicano piuttosto alla ristrutturazione, come nell'Angelina. Anche qui, come nel loro primo ristorante e nei vari club, i due ex atleti puntano su un arredamento adeguato. A questo ci pensa Luigi, che quando vede un ambiente, sa già come va arredato, dalle sedie al colore delle pareti fino alle decorazioni. E siccome Luigi è un grande ammiratore della Francia, si riconoscono spesso qua e là piccoli omaggi al Paese limitrofo.

Like a loft decorated with photos and paintings, Gusto's Osteria is spread out over several rooms and levels and now offers typical Roman food in addition to a pizzeria and restaurant. There, right next to Piazza Augusto Imperatore, a mostly local clientele enjoys classic dishes such as pasta alla carbonara, amatriciana, or cacio e pepe. The cheese accompanying the meals comes from the adjacent cheese bar stocked with more than 200 varieties.

Wie ein Loft, dekoriert mit Fotos und Gemälden, verteilt sich die Osteria des Gusto auf verschiedene Räume und Ebenen und bietet gleich bei der Piazza Augusto Imperatore neben Pizzeria und Restaurant nun auch typisch römische Küche. Dort findet ein hauptsächlich römisches Publikum wohlbekannte Gerichte – neben der Pasta Carbonara auch die Amatriciana oder die Cacio e Pepe. Der dazugehörige Käse kommt aus dem angrenzenden Käseraum, der mit über 200 Sorten bestückt ist.

Similaire à un loft et décorée de photos et peintures, l'Osteria de Gusto s'étend sur plusieurs salles et niveaux. Située à côté de la pizzeria et du restaurant du même nom sur la Piazza Augusto Imperatore, on y propose de la cuisine typiquement romaine. Une clientèle exclusivement romaine y déguste des plats connus comme la Pasta carbonara, Amatriciana ou Cacio e pepe. Le fromage en accompagnement provient de la région voisine où sont produites plus de 200 sortes de fromages.

Decorata con fotografie e dipinti, l'Osteria Gusto, proprio in Piazza Augusto Imperatore, si sviluppa in diversi ambienti e su vari livelli a guisa di loft e oggi, accanto al servizio ristorante-pizzeria, offre anche cucina tradizionale romana. I clienti, prevalentemente romani, ci vengono per gustare piatti classici come pasta alla carbonara, all'amatriciana o cacio e pepe. I formaggi utilizzati provengono dall'attigua formaggeria, che si avvale di ben 200 varietà.

GUSTO – L'OSTERIA

Via della Frezza 16/Vicolo del Corea // Centro Storico
Tel.: +39 06 32 11 14 82
www.gusto.it/osteria-roma.htm

Daily 12.45 pm to 3 pm and 7.45 pm to midnight
Bus 590 Ripetta / Fiume
Bus 628 Passeggiata Ripetta

After the restoration of the Palazzo delle Esposizioni was completed, internationally renowned chef Antonello Colonna moved into the top floor, designed by architect Paolo Desideri. On two levels, Open Colonna presents his innovative reinterpretations of traditional Italian dishes, not only à la carte for lunch and dinner, but also for brunch on weekends and at special events. Thirsty patrons can enjoy drinks in the bar or on the two terraces.

Mit der Restaurierung des Palazzo delle Esposizioni zog Chefkoch Antonello Colonna in das von Architekt Paolo Desideri gestaltete oberste Stockwerk ein, wo er seitdem auf zwei Ebenen seine neu interpretierten traditionellen Gerichte der italienischen Küche präsentiert. Und zwar nicht nur à la carte mittags und abends, sondern auch als ausgiebigen Brunch am Wochenende und zu außergewöhnlichen Events. Für Durstige bietet sich ein Stopp an der Bar oder auf einer der beiden Terrassen an.

Depuis la rénovation du Palazzo delle Esposizioni, le chef cuisinier Antonello Colonna occupe le dernier étage du palais, aménagé par l'architecte Paolo Desideri. Situé sur deux niveaux, son restaurant propose des plats revisités de la cuisine italienne traditionnelle, qui sont disponibles à la carte le midi et le soir et en formule brunch les week-ends et lors d'événements exceptionnels. On peut aussi simplement prendre un verre au bar ou sur l'une des deux terrasses.

Dopo il restauro di Palazzo delle Esposizioni, il capocuoco Antonello Colonna si è trasferito al piano superiore dell'edificio, realizzato dall'architetto Paolo Desideri, dove da allora propone in un ambiente distribuito su due livelli piatti tradizionali della cucina italiana rivisitati in chiave moderna: pranzi e cene à la carte ma anche sontuosi brunch nei fine settimana e in occasione di eventi straordinari. Per bere qualcosa merita fare un salto al bar o in una delle due terrazze.

OPEN COLONNA

Via Milano 9/a // Centro Storico
Tel.: +39 06 47 82 26 41
www.antonellocolonna.it

Tue–Sat 12.30 am to 3 pm and
7.30 pm to 10 pm, Sun 12.30 am to 3.30 pm
Bus 40, 64, 70, 71, 117 Nazionale / Palazzo Esposizioni

RHOME

Piazza Augusto Imperatore 42 // Centro Storico
Tel.: +39 06 68 30 14 30
www.ristoranterhome.com

Mon–Fri 12.30 am to 3 pm and 8.30 pm to 2 am,
Sat–Sun 8.30 pm to 2 am
Bus 913 Augusto Imperatore

rHome

Its name perfectly expresses rHome's mission: to make guests feel right at home. And they seem to, because this elegant restaurant on the Piazza Augusto Imperatore has been in business for ten years now, serving exquisite Italian dishes and wines from nearly all of Italy's wine-growing regions in a space encompassing two levels. On certain days, parts of the restaurant become a disco after midnight, providing entertainment for night owls.

Wie zu Hause sollen sich die Gäste fühlen, daher auch das „Home" im Namen des Lokals. Und offenbar tun sie das auch, denn seit nunmehr zehn Jahren gibt es das schicke Lokal an der Piazza Augusto Imperatore, das auf zwei Ebenen raffinierte italienische Küche und dazu Weine aus fast allen Regionen Italiens anbietet. Wer sich an den Köstlichkeiten gelabt hat, kann den Abend in der Disco ausklingen lassen, in die das Restaurant nach Mitternacht teilweise verwandelt wird.

Les clients doivent s'y sentir comme chez eux ; c'est ce que sous-entend « rHome ». Et c'est apparemment le cas car depuis dix ans, cet élégant restaurant de la Piazza Augusto Imperatore propose sur une surface de deux étages une cuisine italienne raffinée et des vins de presque toutes les régions du pays. Après s'être délectés de plats succulents, les clients pourront terminer la soirée sur la piste de danse du restaurant, transformé en discothèque à partir de minuit.

Gli ospiti si devono sentire a casa, da qui la parola "Home" nel nome di questo elegante locale di due piani situato in Piazza Augusto Imperatore. Evidentemente è proprio così che qui ci si sente, poiché è da oltre un decennio che il locale offre raffinati piatti di cucina italiana abbinati a vini di quasi tutte le regioni dello stivale. Dopo un pieno di prelibatezze culinarie, ci si può abbandonare alla discoteca a cui parte del locale viene adibita dopo la mezzanotte.

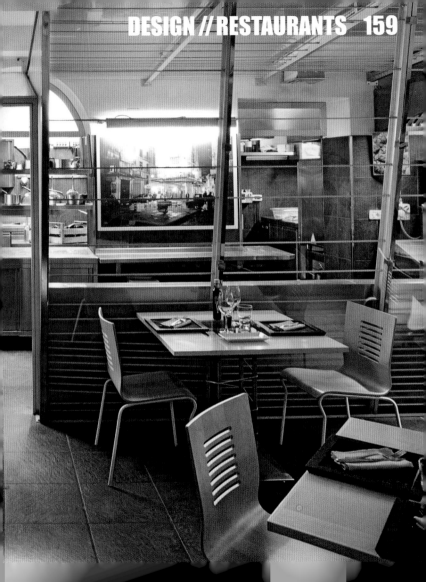

Ristorante Trattoria is located in a grand palazzo from the 17th century near Piazza Navona. However, if the word "trattoria" puts you in a rustic frame of mind, you'll be pleasantly surprised. With light woods and multi-hued metallic surfaces, the interior of the bar and restaurant, designed by Marco and Gianluigi Giammetta, is completely modern. A long wall of glass separating the kitchen from the dining room lets you watch the chefs at work.

Nahe der Piazza Navona befindet sich das Ristorante Trattoria in einem herrschaftlichen Palazzo aus dem 17. Jahrhundert. Wer bei „Trattoria" allerdings an ein rustikales Ambiente denkt, irrt. Mit hellen Holztönen und verschiedenfarbigen Metallflächen ist die Einrichtung von Bar und Restaurant, gestaltet von den Designern Marco und Gianluigi Giammetta, absolut modern. Und dank einer langen Glaswand, die die Küche vom Speisesaal trennt, kann man den Köchen sogar bei der Arbeit zuschauen.

Le restaurant Trattoria se situe dans un palais majestueux du XVIIe siècle à proximité de la Piazza Navona. Celui qui s'attend à y rencontrer une ambiance rustique sera déçu. La salle moderne aux boiseries claires et plaques métalliques fut aménagée par les designers Marco et Gianluigi Giammetta. La paroi de verre séparant la cuisine de la salle de restaurant permet aux clients de contempler le travail de maître des cuisiniers.

Il ristorante Trattoria è ospitato in un palazzo del XVII secolo nei pressi di Piazza Navona. Non fatevi ingannare dal nome, perché l'ambiente che offre non è rustico, bensì assolutamente moderno. Il bar e il ristorante, progettati da Marco e Gianluigi Giammetta, sono caratterizzati da calde tonalità del legno e superfici metalliche di vari colori, e grazie a un'ampia vetrata che separa la cucina dalla sala da pranzo si possono persino vedere i cuochi all'opera.

TRATTORIA

Via del Pozzo delle Cornacchie 25 // Centro Storico
Tel.: +39 06 68 30 14 27
www.ristorantetrattoria.it

Mon–Fri 12.30 am to 3.15 pm and
7.30 pm to 11 pm, Sat 7.30 pm to 11 pm
Bus 70 Senato, Bus 492 Senato

At Ristorante Angelina near Piazza San Silvestro and the Parliament, owners Luigi and Toni have found the perfect balance to cater to their guests. At noontime, there is a lunch buffet with a wide range of choices; in the evening, dinner is served à la carte; and on Sundays an extensive apéritif selection is offered. In the adjacent bar, gourmets find attractively wrapped homemade desserts and tasty treats for smaller appetites.

Mit dem Angelina in der Nähe der Piazza San Silvestro und des Parlaments haben die Macher Luigi und Toni einen Nerv getroffen. Zur Mittagszeit wartet ein reichhaltiges Buffet auf die Gäste, doch auch darüber hinaus werden sie im Angelina bestens versorgt: Abends gibt es Essen à la carte und Sonntags einen umfangreichen Aperitif. In der nebenan liegenden Bar finden Gourmands liebevoll verpackte, hausgemachte Desserts und kulinarische Leckerbissen für den kleinen Hunger.

Située non loin de la Piazza San Silvestro et du Parlement, le restaurant Angelina fait la fierté de ses propriétaires Luigi et Toni. Le midi, un buffet copieux attend les clients qui ne manqueront pas de se faire gâter. Le soir, on y mange à la carte et l'apéritif du dimanche n'est à manquer sous aucun prétexte. Dans le bar attenant, les gourmands pourront savourer d'excellents desserts faits maison et des encas pour les petites faims.

Con l'Angelina, vicino a Piazza San Silvestro e alla sede del Parlamento, i due fondatori Luigi e Toni hanno proprio colpito nel segno. Ad attendere gli ospiti a pranzo c'è un sontuoso buffet, ma da Angelina si è in buone mani anche in qualsiasi altro momento: la sera c'è un menu à la carte e la domenica un ricco aperitivo. Nell'attiguo bar i buongustai troveranno dolci fatti in casa dall'aspetto molto invitante e spuntini che sono autentiche prelibatezze culinarie.

ANGELINA

Via Galvani 24/a // Testaccio
Tel.: +39 06 57 28 38 40
ristoranteangelina.com

Daily 8 pm to midnight
Metro B Piramide

MIA

Via di Ripetta 224 // Centro Storico
Tel.: +39 06 97 84 18 92
www.miaviadiripetta.com

Mon 4 pm to 8 pm,
Tue–Sat 10.30 am to 2 pm and 4 pm to 8 pm
Metro A Flaminio, Bus 119 Babuino

Located in a former convent, Mia has become a fixture in the design world of Rome. The style of the furniture and decorative objects ranges from vintage to contemporary and futuristic; most items are one of a kind or rarities. As different as the individual pieces might be, they have one thing in common: they are all handcrafted. If you're not yet sure how to dress up your home, you can look for inspiration in the many magazines and books at hand.

In einem früheren Konvent bereicher das Mia seit einigen Jahren die römi sche Designwelt. Der Stil der Möbe und Dekorationsgegenstände reicht vor Vintage bis zum Zeitgenössischen und Futurismus, meist handelt es sich um Einzelstücke oder Raritäten. Doch so ver schieden die Stücke untereinander sind so verbindet sie doch der handwerkliche Aspekt. Wer noch nicht wirklich weiß wie er sein Zuhause verschönern könnte findet in zahlreichen Magazinen und Bü chern Inspiration.

Depuis quelques années, le Mia, situé dans un ancien couvent, fait honneur au monde du design romain. Les meubles et objets de décoration, souvent des pièces uniques et rares, vont du vintage au style contemporain, en passant par le futurisme. Les articles sont tous artisanaux. Celui qui ne sait pas encore comment embellir son chez soi, pourra s'inspirer des magazines et livres proposés.

Ospitato in un ex monastero, il Mia è una nuova stella di cui si pregia da alcun anni il firmamento del design di Roma Il negozio presenta quasi esclusivamente pezzi unici o rari che spaziano dal vinta ge all'epoca moderna fino al futurismo Oggetti molto dissimili tra loro, ma ac comunati dal taglio artigianale. Quant non hanno le idee ben chiare su come abbellire la propria dimora, troveranno ispirazione in numerosi libri e riviste.

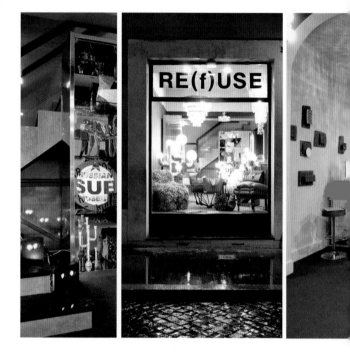

RE(F)USE

Via Fontanella Borghese 40 // Centro Storico
Tel.: +39 06 68 13 69 75
www.carminacampus.com/refuse.html

Mon 3 pm to 7 pm,
Tue–Sat 10 am to 7 pm
Metro A Spagna

Re(f)use is a boutique selling furniture, clothes, and jewelry made exclusively from recycled or reused materials to demonstrate to customers that it is possible to be both fashion- and eco-conscious. Their motto "Save waste from waste" is embodied in the many bags and accessories that showcase the enormous creativity of international and Italian artists—and especially Carmina Campus, who opened the boutique.

Das Re(f)use ist eine Boutique, die Möbel, Kleidung und Schmuck ausnahmslos aus recycelten oder wiederverwendeten Materialien verkauft, um einen anderen Zugang zum Konsum zu zeigen. „Save waste from waste", also ungefähr „Bewahre Abfall vor dem Abfall" ist deshalb auch das Motto, das sich au zahlreichen Taschen und Accessoires wiederfindet, die von enormer Kreativität der internationalen und italienischer Künstler zeugen – allen voran von Carmina Campus, die die Boutique eröffnet hat.

La boutique Re(f)use présente un nouvel aspect de la consommation en vendant exclusivement des meubles, vêtements et bijoux à base de matériaux recyclés et de seconde main. « Save waste from waste » - « Sauve les déchets de la déchetterie » constitue la devise que l'on retrouve dans chaque article. Sacs et accessoires sont le fruit de l'immense créativité dont font preuve les artistes internationaux et italiens, et plus particulièrement la créa-

Re(f)use è un negozio che vende mobili, vestiti e gioielli in materiale rigorosamente riciclato o riutilizzato proponendo un nuovo modo di avvicinarsi al consumismo. "Save waste from waste", che grossomodo significa "Salva i rifiuti dai rifiuti", è il suo motto, che si rispecchia in numerose borse e accessori che attestano la creatività di artisti nazionali e internazionali – primi fra tutti Carmina Campus, fondatrice del negozio stesso.

D

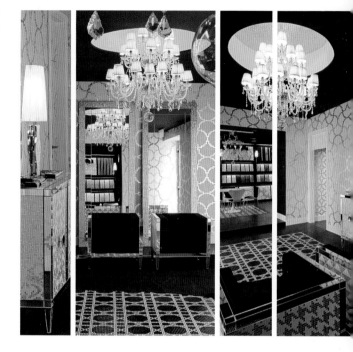

SPAZIO BISAZZA

Piazza di Firenze 25 // Centro Storico
Tel.: +39 06 68 96 76 8
www.bisazza.it

Mon 2 pm to 7 pm,
Tue–Sat 10 am to 1 pm and 2 pm to 7 pm
Metro A Spagna

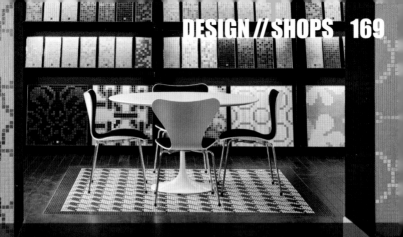

After its flagship store opened in Milan, Italy's design capital, the next logical step for Bisazza was to open a branch in Rome as well. Bisazza's own design studio headed up by architect Carlo Dal Bianco and his team was in charge of the design of the business, opened in 2002. Mosaics decorate the walls, floors, and ceilings of the four different showrooms where shoppers can browse mosaic patterns in all available colors and be inspired for their own decorating projects.

Nach einem Flagship-Store in der italienischen Designmetropole Mailand durfte für Bisazza auch eine Dependance in Rom nicht fehlen. Dem eigenen Design Studio unter der Leitung des Architekten Carlo Dal Bianco und seinem Team ist die Gestaltung des 2002 eröffneten Geschäfts zu verdanken. Mosaike schmücken die Wände, Fußböden und Decken der vier unterschiedlichen Räume, in denen Mosaikdekore in allen erdenklichen Farben präsentiert werden – als Anregung für eine zukünftige Einrichtung.

Après avoir ouvert un magasin phare dans la métropole milanaise du design, il était impératif qu'une succursale Bisazza ouvre ses portes à Rome. Inaugurée en 2002, cette boutique doit son décor à l'architecte Carlo Dal Bianco et son équipe de Bisazza Design Studio. Les murs, sols et plafonds en mosaïques des quatre salles différentes présentent des décors où toutes les couleurs trouvent leur place – une belle inspiration pour votre intérieur.

Dopo un flagship store a Milano, nella capitale italiana del design, non ne poteva mancare uno a Roma. Allo studio interno di design guidato da Carlo Dal Bianco e al suo team si deve l'arredamento del negozio, inaugurato nel 2002. I mosaici adornano pareti, pavimenti e soffitti delle quattro stanze in cui vengono presentate decorazioni a mosaico in tutti i colori immaginabili, fornendo nuove idee per un futuro arredamento.

Candles, cards, plates, towels, lamps, and furniture—there is little you cannot get at Spazio Sette, in business for over 35 years. Spread out over several levels in an old palazzo, the store sells pieces mostly by northern European but also by Italian designers. As you explore the store, be sure to visit the first floor which is used for special presentations and is decorated with frescoes.

Kerzen, Karten, Teller, Handtücher, Lampen und Möbel – es gibt wahrscheinlich wenig, was es im Spazio Sette nicht gibt – und das seit über 35 Jahren. In einem alten Palazzo verteilt sich die Ausstellungsfläche auf mehreren Ebenen, wo Werke vor allem nordeuropäischer, aber natürlich auch italienischer Designer präsentiert werden. Lohnend bei einem Gang durch das Geschäft ist auch ein Blick auf den mit Fresken geschmückten zweiten Stock, der auch für besondere Präsentationen genutzt wird.

Que vous cherchiez des bougies, cartes, assiettes, serviettes, lampes ou meubles, il y a peu de choses que le Spazio Sette ne propose pas et cela dure depuis plus de 35 ans. Située dans un vieux palais, la boutique présente sur plusieurs étages des œuvres de designers du nord de l'Europe, mais également d'Italie. Le deuxième étage, souvent utilisé pour des expositions spéciales, comporte des fresques qui valent le détour.

Candele, cartoline, piatti, asciugamani, lampade e mobili – è davvero poco quello che non si riesce a trovare a Spazio Sette – da più di 35 anni. All'interno di un palazzo antico, gli spazi espositivi del negozio si sviluppano su più piani, dove vengono presentate creazioni di designer nordeuropei, ma naturalmente anche italiani. Visitando il negozio, merita dare un'occhiata agli affreschi che decorano il secondo piano, utilizzato anche per presentazioni speciali.

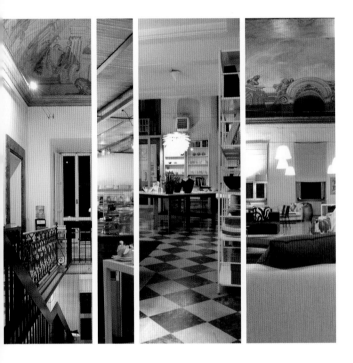

SPAZIO SETTE

Via dei Barbieri 7 // Centro Storico
Tel.: +39 06 68 69 74 7
www.spaziosette.it

Mon 3.30 pm to 7.30 pm, Tue–Sat 9.30 am to
1 pm and 3.30 pm to 7.30 pm
Tram 8 Argentina, Bus 64 Argentina

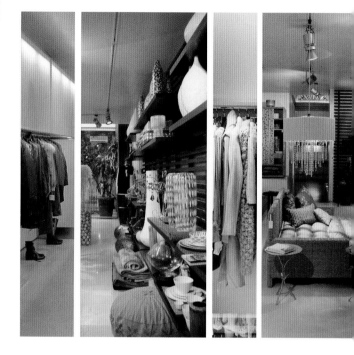

TAD

Via del Babuino 155a // Centro Storico
Tel.: +39 06 96 84 20 86
www.wetad.it

Sun–Mon noon to 7.30 pm,
Tue–Fri 10.30 am to 7.30 pm,
Sat 10.30 am to 8 pm
Metro A Spagna, Bus 119 Babuino

TAD is Rome's first concept store. Its initials stand for the tongue-twisting "Tendenze e antiche debolezze"—Italian for "trends and old weaknesses." On 11,000 sq. ft., it offers decorative objects for the home, clothing, flowers, music and books as well as exhibitions, and occasional cultural events. It is also a place to get away from it all, either in the café-restaurant complete with conservatory, or in the beauty salon as you get your hair done or receive makeup advice.

Das TAD, dessen ausgeschriebener Name „Tendenze e antiche debolezze" für Trends und alte Schwächen steht, ist der erste Concept Store Roms und bietet auf rund 1 000 m² Dekorationsgegenstände für das traute Heim, Kleidung, Blumen, Musik, Bücher, Ausstellungen und hin und wieder kulturelle Events. Nicht zu vergessen die Möglichkeit, mal ein bisschen auszuspannen – im Café-Restaurant mit Wintergarten oder bei einer Schönheitsbehandlung bei Friseur oder Makeup-Beratung.

Le TAD, dont les initiales signifient « Tendenze e antiche debolezze » - tendances et faiblesses antiques, est le premier concept-store de Rome. Objets de décoration, vêtements, fleurs, CDs et livres sont exposés sur 1 000 m². Des expositions et événements culturels y ont régulièrement lieu. Et n'oublions pas le côté détente en prenant un café au restaurant doté d'un jardin d'hiver ou lors d'une séance beauté chez le coiffeur ou

Il TAD, che sta per "Tendenze e antiche debolezze", è il primo concept store di Roma e offre sue 1 000 m² oggetti decorativi per il focolare domestico, abbigliamento, fiori, musica, libri, esposizioni e di tanto in tanto eventi di carattere culturale. Per non parlare delle occasioni di relax, nel caffè-ristorante ospitato nel giardino d'inverno oppure con un trattamento di bellezza in un salone di parrucchiere o da un esperto di makeup.

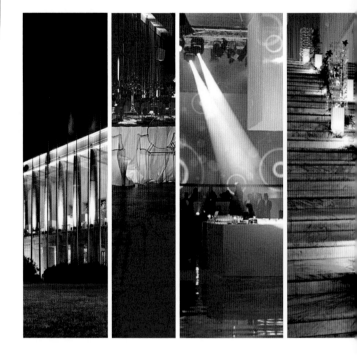

SPAZIO NOVECENTO

Piazza Guglielmo Marconi 26/B // EUR
Tel.: +39 06 54 22 11 07
www.spazionovecento.it

Office: Mon–Fri 10 am to 6 pm
Metro B Palasport

Spazio Novecento is located on the first floor of the Palazzo dell'Arte Antica right in the heart of Rome's EUR district. A 210 ft. rectangular hall equipped with video and sound systems as well as state-of-the-art lighting seats 600 visitors. In the summer, it can accommodate even larger groups thanks to a huge terrace. With its flexible configuration, Spazio Novecento can host events of all types, from fashion shows and conventions to concerts and special celebrations.

Im ersten Stock des Palazzo dell'Arte Antica mitten im EUR-Viertel befindet sich der Spazio Novecento. In dem 64 m langen rechteckigen Saal, der mit Audio-, Video- und einer hochmodernen Lichtanlage ausgestattet ist, finden bis zu 600 Gäste Platz. Noch mehr können es sein, wenn im Sommer die riesige Terrasse in die Veranstaltung einbezogen wird. Egal ob Modeschauen, Kongresse, Konzerte oder besondere Feiern - die flexible Ausstattung ermöglicht Events jeder Art.

Le Spazio Novecento se situe au premier étage du Palazzo dell'Arte Antica au milieu du quartier EUR. Cette salle rectangulaire de 64 m de long, équipée d'une installation audio et vidéo ainsi que d'un éclairage ultra moderne, peut accueillir 600 personnes. En été, la terrasse permet de recevoir plus d'invités. L'agencement flexible permet d'accueillir toutes sortes d'événements, qu'il s'agisse de défilés de mode, congrès, concerts ou célébrations spéciales.

Spazio Novecento si trova al primo piano del Palazzo dell'Arte Antica, al centro del quartiere EUR. La sala rettangolare, lunga ben 64 m e dotata di impianto audio e video e di un modernissimo sistema di luci, può ospitare fino a 600 ospiti. In estate potranno essere anche di più, organizzando eventi sull'ampia terrazza. Che si tratti di sfilate di moda, congressi, concerti o feste particolari, la flessibilità degli impianti permette di ospitare eventi di ogni tipo.

AVENTINO

The lowest of the seven hills is also the loveliest. Despite its proximity to the center it is very calm, and from the Giardino degli Aranci -named after its orange trees- you can enjoy a wonderful view onto the Trastevere and the dome of St. Peter's.

ART

ARCHITECTURE

MAP 177

CENTRO STORICO

The historical center reaches from the station to the Tiber bend, but most sight-seeing opportunities can be found in just a small area, which has become a popular shopping destination thanks to its boutiques.

DESIGN

CIRCO MASSIMO

The south of the center is characterized by its ancient ruins: the Palatine hill dominates the skyline above the Circo Massimo, where the shape of the former racecourse can still be made out. The Caracalla thermae are just a hundred meters away.

ESQUILINO

This district lies on one of the seven hills of Rome, with its outstanding churches, Santa Maria Maggiore and Santa Prassede. Ordinary life plays out in the Piazza Vittorio—even in the early hours of the morning at the market.

EUR

The EUR district was brought into being for the World Exhibition in 1942, although this never actually took place due to the Second World War. It is a district of art, business and residency in equal measure, containing buildings erected by great architects of the period.

FLAMINIO

This district is something of a place of pilgrimage for lovers of architecture, thanks to Renzo Piano's auditorium and Zaha Hadid's MAXXI.

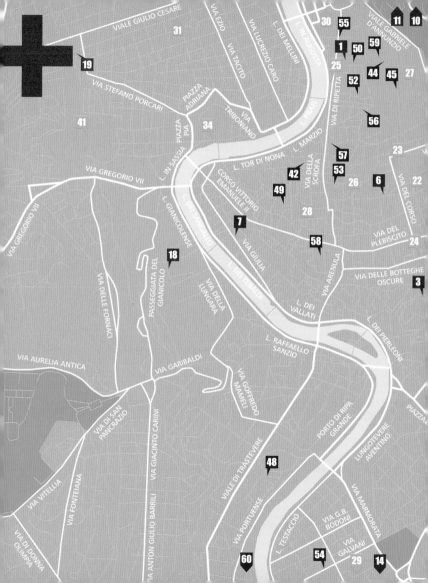

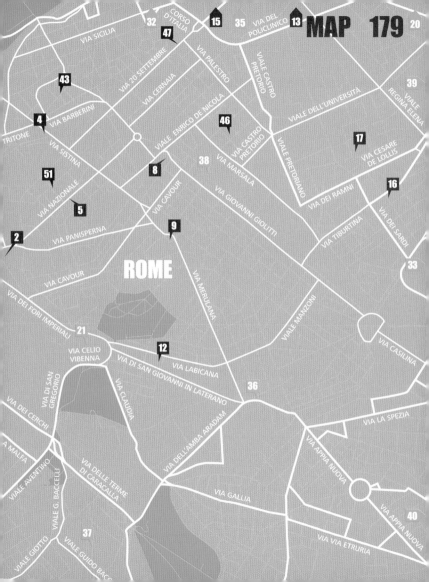

NOMENTANO

Popular residential district with the large Villa Torlonia and Villa Ada parks.

OSTIENSE

The Gasometer, immortalized in so many films, is the symbol of this district, whose lively nightlife has come with the construction of the Third University. For those interested in culture, the Centrale Montemartini museum is a must.

PORTA PIA / SALARIO

This city gate designed by Michelangelo took on strategic importance during the last battle for the unification of Italy in 1870. Setting out from the center on foot you come through the Salario area–since MACRO has made its home here it has become an attractive destination for fans of art.

SAN LORENZO

This student-filled district is understandably filled with bars and pizzerias that are great value for money as well as good quality. San Lorenzo, which contains the famous San Lorenzo fuori le Mura church, has recently become a nearly traffic-free zone on weekends.

TESTACCIO

Bars, clubs and restaurants come one after another in this authentic area south of the center, and in the redeveloped former slaughterhouse regular cultural events are put on.

TOR TRE TESTE/CASAL BOCCONE/PONTE DI NONA/ COLLATINO

These outlying districts are rather austere in themselves, but do have architectural highlights to offer–including the churches by Richard Meier and Garofalo Miura.

TRASTEVERE

Pretty houses and narrow alleyways are what characterize this part of town. In summer stalls, bars and restaurants open right on the banks of the Tiber, attracting many strolling visitors. It is worth a walk up the Gianicolo hill, which offers the best views of Rome and the surrounding mountains.

VATICANO

The Vatican is not a Roman district, but rather the smallest nation state in the world, not to mention the center of the global Catholic church.

EMERGENCY

Ambulance Tel.: 118
Fire Tel.: 115
Police Tel.: 113

ARRIVAL

BY PLANE
Rome has two international airports within easy reach of the city center.
Information: Tel. +39 / 06 / 6 59 51
www.adr.it

AEROPORTO LEONARDO DA VINCI FIUMICINO (FCO)
32 km/20 miles west of the city center. Scheduled and charter flights. To the city center, take the Leonardo-Express to Stazione Termini (ca. 30 min), Regional service FM1 to Tiburtina Station (ca. 45 min).
www.trenitalia.com
There is also a bus shuttle (ca. 70 min).
www.terravision.it

AEROPORTO ROMA CIAMPINO (CIA)
15 km/9 miles south east of the city center. Former military airport, charter and budget flights. Cotral busses to Anagnina metro station (15 min). Take metro line A to Stazione Termini.
http://www.cotralspa.it.
Shuttle bus service to Termini (ca. 30 min).
www.terravision.it

BY TRAIN
ROMA TERMINI
Piazza dei Cinquecento
www.romatermini.it
Rome's Central Station is located right in the city center with a direct connection to metro linea A and linea B.
Tel. +39 / 06 / 4 88 17 26

www.trenitalia.com
Rome also boasts 5 further railway stations: Roma TIBURTINA, Roma OSTIENSE, Roma TUSCOLANA, Roma TRASTEVERE, and Roma SAN PIETRO,
Tel. +39 / 89 20 21 (0,54€/min.)

TOURIST INFORMATION

ROMA
AZIENDA DI PROMOZIONE TURISTICA (APT)
Via Parigi 5
00185 Roma
Tel. +39 / 06 / 48 89 91
Fax. +39 / 06 / 4 81 93 16
info@aptroma.com
www.romaturismo.com

Mon–Sat 9.30 am to 7 pm
Sub-office in Leonardo da Vinci airport, terminal B, daily 8.15 am to 7 pm. Numerous information stands P. I. T. dotted around the city incl. the Stazione Termini, Via Nazionale, Piazza Navona, Castel Sant' Angelo.

www.romaturismo.com
The Roman tourism information portal with a comprehensive accommodation guide and well-arranged event calendar

www.comune.roma.it
The city council's official website

www.vatican.va
Official Vatican portal, incl. information of the liturgical year as well as the Vatican's museums and libraries

SPORT & LEISURE

www.parcoappiaantica.org - all you need to know about the regional park Appia Antica

www.termediroma.org - Tivoli spa

www.villaborghese.it - leisure facilities in the park of the Villa Borghese

ACCOMMODATION

www.alberghi.romaturismo.it - list of accommodation by the Roman tourist board incl. web-links.

www.bbitalia.it - bed & breakfast across Italy incl. Rome.

www.romeby.com - hotels, guesthouses, and rooms, vacation rental.
www.romaclick.com - hotels, bed & breakfast, vacation rental.

TICKETS

HELLÒ TICKET
Tel. +39 / 06 / 48 07 84 00
www.helloticket.it
Box office: Orbis Servizi, Piazza Esquilino 37

TICKETERIA
Tel. +39 / 06 / 3 28 10
Fax. +39 / 06 / 32 65 13 29
www.ticketeria.it
Ticket service for a number of Roman museums, some of which require advance notification.

REDUCTIONS
Roma Pass
Free public transport and free entry to two museums, as well as reduced prices for many other museums and events. Available from the Roman tourist board, museums, and online under **www.ticketclic.it**, 3 day pass 20 euros, **www.romapass.it**

MUSEUM PASS
Three strip tickets reduce entry to museums and other places of interest. They are valid for seven days and available from the Roman tourist board, museums, or online from **www.ticketclic.it**

Roma Archeologica Card (Colosseo, Palatino, Palazzo Massimo, Palazzo Altemps, Crypta Balbi, Terme di Diocleziano, Terme di Caracalla, Tomba di Cecilia Matella, Villa dei Quintili), 23.50 euros

Capitolini Card (Musei Capitolini, Centrale Montemartini), 9 euros

Appia Antica Card
(Terme di Caracalla, Tomba di Cecilia Metella, Villa dei Quintili), 7.50 euros

GETTING AROUND

PUBLIC TRANSPORTATION
www.atac.roma.it
Official website of Roman Public Transport, also in English
Tel. +39 / 06 / 5 70 03

TAXI
Tel. +39 / 06 / 55 51
Tel. +39 / 06 / 49 94
Tel. +39 / 1 99 60 11 06

BICYCLE, SCOOTER AND VESPA RENTAL
www.scooterhire.it

BIKE E SCOOTER RENTAL
Via Cavour 80
Tel. +39 / 06 / 4 81 56 69
Open: 9 am to 7 pm
www.ecomoverent.com

BICYCLES, SCOOTERS, AND MOTORBIKES
Via Varese 48-50
Tel. +39 / 06 / 44 70 45 18
Daily 8.30 am to 7.30 pm

BICI PINCIO
Viale de Villa Medici (Villa Borghese)
Tel. +39 / 06 / 6 78 43 74

INFORMATION POINT
Via Appia Antica 58/60
Tel. +39 / 06 / 5 13 53 16
Mon-Sat 9.30 am to 5.30 pm or 4.30 pm during the winter months

CITY TOURS

BUSES AND STREETCARS
Public transport is ideal for reasonably priced city tours.
Electro bus lines 116, 117, and 119 for old part of town.
The expressline 40 and bus line 64 from Vatican to Stazione Termini.
Bus line 170 for Termini to Trastevere.
Streetcar line 3 from Trastevere to Villa Borghese

SIGHTSEEING BUSES
www.trambusopen.com
Double decker bus line 110.
The hop-on-hop-off system includes ten stops, commentary in Italian and English, tickets for the day costs 13 euros.

16 seater Archeobus.
From the central railway station to the antique center of the Via Appia Antica. Combined ticket for both tours 20 euros.
Tel. +39 / 8 00 28 12 81

www.appianline.it
Appia Line
Piazza dell'Esquilino 6/7

www.spettacoloromano.it
Contains the program of around 50 theaters in and around Rome.
Tel. +39 / 06 / 48 78 66 01

BOAT TOURS
www.batellidiroma.it
Batelli di Roma
Tel. +39 / 06 / 97 74 54 98
Boat service between Isola Tiberina / Calata Aguillara and Ponte Duca D'Aosta

BYCICLE TOURS
The extensive park of Villa Borghese is ideal for a bike tour. Via Appia Antica is just as appealing on Sundays, when it is closed to cars. A mountain bike is best suited for the up to 20km/12 mile long bumpy ride.

GUIDED TOURS
www.enjoyrome.com
Enjoy Rome
Via Marghera 8a
Tel. +39 / 06 / 44 51 84 3

www.romaculta.it
RomaCulta
Tel. +39 / 33 87 60 74 70

Individual city tour and cultural guided walks. Reservation required.

ART & CULTURE

www.beniculturali.it
Ministry of culture's website with links to main museums and archaeological sites.

www.museiincomuneroma.it
Official portal of roman museums.

www.museionline.it
Museums, exhibitions, and excavations all over Italy.

www.auditorium.com
The modern concert hall's portal incl. program.

www.spettacoloromano.it
Contains the program of around 50 theaters in and around Rome.

www.arteroma.com/pgante.htm
Virtual gallery dedicated to contemporary artists

www.casadellarchitettura.it
Cultural institution which promotes roman architectural culture and contemporary architecture through exhibitions, awards, conferences and meetings

www.architettiroma.it
Website of the architectural association of Rome and the province with information about events, trips, seminars, meetings and competitions

www.fondazionemaxxi.it/it/eventi/elenco
Events about Arts and Architecture of the MAXXI foundation

www.zetema.it/
Information about exhibitions and initiatives of the Roman Civic Museums and other sites supervised by the IV. department of the Roman municipality as well as events organized by the Roman municipality

GOING OUT

http://www.romace.it/home
Weekly magazine featuring events, cinema, arts, theatre and special visits to museums, archeological sites and usually closed buildings.

www.timeout.com/rome
Restaurants and bars, shopping, nightlife, event guide.

www.2night.it
Restaurants and bars, aperitifs, nightlife, event guide.

http://www.trova-roma.com/
Restaurants, hotels, shops, doctors, and all sorts of services.

EVENTS

Befana
January 5/6, the witch Befana rides on her broom from house to house to present well-behaved children with a sock full of sweets. Epiphany market with lots of gift articles and souvenirs on the Piazza Navona.

Maratona
Middle of March, city marathon (www.maratonadiroma.it)

Feste delle Palme
Sunday before Easter, festive sanctification of olive branches on St. Peter's Square.

Pasqua
Easter, Holy Thursday: the Maundy in the Basilica of St. John Lateran; midnight papal mass on Good Friday on Palatine Hill and the cross procession at the Colosseum; papal blessing "Urbi et Orbi" at noon on Easter Sunday on St. Peter's Square.

Natale di Roma
April 20/21, festival on the Capitoline Hill celebrating the founding of Rome with flag tossers, bands, and fireworks (**www.gsr-roma.com**).

Festa del Lavoro
May 1, Labor Day, free pop concert on the Piazza San Giovanni with national and international stars.

The Road to Contemporary Art
(**www.romacontemporary.it/en/index.html**) May, fair dedicated to contemporary art which presents national and international galleries in a former slaughterhouse

Estate Romana
Middle of June to Middle of Sept., Roman cultural summer with a plethora of events (**www.estateromana.comune.roma.it**).

San Pietro e Paolo
June 29, celebratory papal mass in St. Peter's Basilica to honor St. Peter.

Tevere Expo
July booths selling arts, crafts and culinary tidbits from Roman provinces at the shore of the River Tiber.

L'Isola del Cinema
June–Sept., open-air cinema on Tiber Island (**www.isoladelcinema.com**).

Festa de' Noantri
Second half of July, two-week folk festival in Trastevere with procession, folk dancing, songs, culinary delicacies, and fireworks.

Madonna della Neve
August 5, lavish light show and deployment of snow cannons in remembrance of the wondrous creation of the church Santa Maria Maggiore.

Festa Internazionale di Roma
Middle of October, international film festival (**www.romacinemafest.org**).

Natale
Middle of December–January 6, Christmas market on the Piazza Navona, nativity scenes in numerous churches, midnight mass in St. Peter's Basilica on 24, papal blessing "Urbi et Orbi" on St. Peter's Square at noon on Christmas Day.

Vigiglia di Capodanno
New Year's Eve, public concerts on the Piazza del Popolo, Quirinale, and St. Peter's Square (**www.capodanno.roma.it**).

Cover photo courtesy of Radisson Blu ES.Hotel

ART
ARCHITECTURE
DESIGN

Pocket-size Book,
App for iPhone/iPad/iPod Touch
www.aadguide.com

A NEW GENERATION

of multimedia travel guides featuring
the ultimate selection of architectural
icons, galleries, museums, stylish
hotels, and shops for cultural and
art conscious travelers.

VISUAL

Immerse yourself into inspiring
locations with photos and videos.

APP FEATURES

Search by categories, districts, or
geo locator; get directions or create
your own tour.

ISBN 978-3-8327-9433-0

COPENHAGEN
BARCELONA
SHANGHAI
TOKYO
SINGAPORE
BEIJING
VIENNA
PARIS
SYDNEY
HONG KONG
MUNICH
ZURICH
NEW YORK
SAO PAULO
AMSTERDAM
MIAMI
MEXICO CITY
HAMBURG
LONDON
ROME
EMIRATES
CHICAGO
MILAN
BERLIN

COOL CITIES

Pocket-size Book,
App for iPhone/iPad/iPod Touch
www.cool-cities.com

A NEW GENERATION

of multimedia lifestyle travel guides
featuring the hippest most fashionable
hotels, shops, and dining spots for
cosmopolitan travelers.

VISUAL

Discover the city with tons
of brilliant photos and videos.

APP FEATURES

Search by categories, districts, or geo locator;
get directions or create your own tour.

ISBN 978-3-8327-9493-4

BRUSSELS
VENICE
BANGKOK
MALLORCA+IBIZA
NEW YORK
AMSTERDAM
MIAMI
MEXICO CITY
HAMBURG
LONDON
ROME
MILAN
BERLIN
FRANKFURT
STOCKHOLM
BARCELONA
COPENHAGEN
LOS ANGELES
SHANGHAI
TOKYO
SINGAPORE
VIENNA
BEIJING
COLOGNE
PARIS
HONG KONG
MUNICH

© 2011 Idea & concept by Martin Nicholas Kunz, Lizzy Courage Berlin
Selected, edited and produced by Elke Buscher
Texts by Elke Buscher
Editorial coordination: Elke Buscher
Executive Photo Editor: David Burghardt, Photo Editor: Maren Haupt
Copy Editor: Dr. Simone Bischoff, Inga Wortmann
Art Director: Lizzy Courage Berlin
Design Assistant: Christin Steirat
Imaging and pre-press production: Andreas Doria, Hamburg
Translations: Übersetzungsbüro RR Communications Romina Russo,
Heather Bock, Romina Russo (English), Elodie Gallois, Samantha Michaux (French),
Federica Benetti, Romina Russo (Italian)

© 2011 teNeues Verlag GmbH + Co. KG, Kempen

teNeues Verlag GmbH + Co. KG
Am Selder 37, 47906 Kempen // Germany
Phone: +49 (0)2152 916-0, Fax: +49 (0)2152 916-111
e-mail: books@teneues.de

Press department: Andrea Rehn
Phone: +49 (0)2152 916-202 // e-mail: arehn@teneues.de

teNeues Digital Media GmbH
Kohlfurter Straße 41–43, 10999 Berlin // Germany
Phone: +49 (0)30 700 77 65-0

teNeues Publishing Company
7 West 18th Street, New York, NY 10011 // USA
Phone: +1 212 627 9090, Fax: +1 212 627 9511

teNeues Publishing UK Ltd.
21 Marlowe Court, Lymer Avenue, London SE19 1LP // UK
Phone: +44 (0)20 8670 7522, Fax: +44 (0)20 8670 7523

teNeues France S.A.R.L.
39, rue des Billets, 18250 Henrichemont // France
Phone: +33 (0)2 4826 9348, Fax: +33 (0)1 7072 3482

www.teneues.com

While we strive for utmost precision in every detail, we cannot be held
responsible for any inaccuracies, nor for any subsequent loss or damage arising.
Bibliographic information published by the Deutsche Nationalbibliothek.
The Deutsche Nationalbibliothek lists this publication in the
Deutsche Nationalbibliografie; detailed bibliographic data are
available in the Internet at http://dnb.d-nb.de.

Printed in the Czech Republic
ISBN: 978-3-8327-9499-6